⌘THE⌘
BOTANICAL GARDENS
OF SOUTHERN FLORIDA
THROUGH TIME

ANN MARIE O'PHELAN

AMERICA
THROUGH TIME®
ADDING COLOR TO AMERICAN HISTORY

Dedicated with all my love to my two boys, Justin and Christian.

Cover image: Courtesy of Fairchild Tropical Botanic Garden
Back image: Courtesy of Flamingo Gardens and Lorenzo Cassina

AMERICA THROUGH TIME is an imprint of Fonthill Media LLC

First published 2017

Typeset in Mrs Eaves XL Serif Narrow

Published by Arcadia Publishing by arrangement with Fonthill Media LLC
For all general information, please contact Arcadia Publishing:
Telephone: 843-853-2070
Fax: 843-853-0044
E-mail: sales@arcadiapublishing.com
For customer service and orders:
Toll-Free 1-888-313-2665

Visit us on the internet at www.arcadiapublishing.com

Printed and bound by CPI Group (UK) Ltd, Croydon, CR0 4YY

History of
Botanical Gardens

G ardens have been in existence for many thousands of years. In fact, ancient Egyptians planted lush gardens around their temples that were made up of trees, often planted in rows, such as the sycamore fig, willows, pomegranate, and nut trees. The Egyptian gardens also included flowering plants, along with vining fruits, such as grapes and lotus. Walls frequently enclosed the gardens, and some featured ponds that were stocked with fish. Another early civilization known for cultivating gardens were the Romans, who used plants for food and medicinal purposes, as well as for symbolism and celebration to their gods. The gardens were planted next to their palaces and villas, and included statues and sculptures. In the eighth century, monks planted monastic gardens and used the plants for medicinal purposes. During the sixteenth and seventeenth centuries – a period of the Italian Renaissance – physic gardens, concentrating on the medicinal benefits of plants, began to appear.

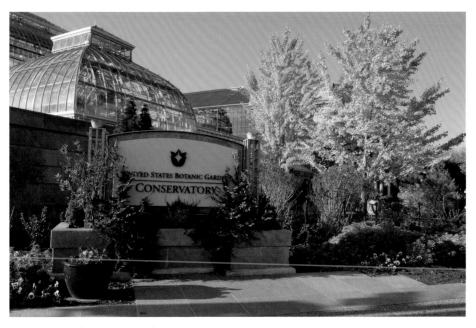

Photo courtesy of US Botanic Gardens.

By the late eighteenth century, botanic gardens were first established in the tropics, although they were initially created to receive and cultivate commercial crops rather than assist with scientific studies. During this same period, economic botany, or the interaction of people with plants, was studied at the Royal Botanic Gardens, Kew, near London. The garden was founded in 1759, and continues to work to increase the understanding of plants and fungus and their many benefits for mankind.

Nowadays, botanic – also referred to as botanical – gardens are designed to inform the public about environmental issues, and the impact of plants on the planet. They serve as learning centers, and are key to the conservation of plants, many of which are threatened species. Key garden personnel carry out documentation, the labeling and monitoring of collections, they also oversee the exchange of seed or other materials with other botanic gardens and institutions, and they conduct research and maintain records.

Botanic gardens are open to the public and are often connected to universities or scientific organizations. There are approximately 2,500 botanic gardens in the world, and about 200 in the United States. The first botanic garden in continuous operation in the United States of America was the Missouri Botanic Garden, established in 1859. The seventy-nine-acre garden is still in operation and is now a historical landmark.

The United States has a botanic garden all its own. The US Botanic Garden has collections dating to the 1840s, when 250 plants and propagation material, gathered by the Wilkes Exploring Expedition (1838-1842), were brought back to Washington, DC. The garden was envisioned by George Washington and established by the US Congress in 1820, making it one of the oldest botanic gardens in North America. The garden features a conservatory, along with jungle, desert, and primeval sections; the National Garden, featuring Mid-Atlantic plants; and Bartholdi Park, a two-acre park with unique plant combinations in a variety of styles and design themes.

In this book, a few of the notable botanic gardens located in the State of Florida will be explored to see how they began, how they have evolved, and what they may look like in the future. The integral role they play in helping educate the public and how they work to preserve the environment will be examined in order to bring public awareness to the importance of these magnificent botanic gardens.

FAIRCHILD TROPICAL BOTANIC GARDEN, CORAL GABLES

Founded as a botanical garden in 1936

In 1936, Fairchild Tropical Botanic Garden was established into the State of Florida by Colonel Robert H. Montgomery. In 1938, it was opened to the public. The garden – the oldest major cultural institution in Miami-Dade County – is named after Dr. David Fairchild (1869-1954), the nation's foremost economic botanist and founder of the US Department of Agriculture Foreign Seed and Plant Introduction Section. A giant African baobab

tree *(Adansonia digitata)*, that was collected by Dr. Fairchild, still grows today. The garden is eighty-three acres in size and includes eleven lakes. Responsible for creating the garden's landscape design was William Lyman Phillips of the Olmsted Group, a group that was chosen to help design New York's Central Park. Phillips was a leading landscape designer during the 1930s, and this garden was one of his most significant projects. Phillips installed individual collections of plants and unified the space by implementing the Bailey Palm Glade to provide a narrow view across the landscape, as well as the Overlook that offers a wide view of the garden's lowland areas and lakes. Also found are numerous plant displays and collections, including The Palmetum – one of the most important documented palm collection in the world – as well as The Lin Lougheed Spiny Forest of Madagascar, The Keys Coastal Habitat, The Geiger Tropical Flower Garden, The Richard H. Simons Rainforest exhibit, The Lisa D. Anness Butterfly Garden, The Arboretum, The Vine Pergola, The Succulent Garden, and The Benjamin Rush Sibley Victoria Amazonica Pool. The 25,000-square-foot Paul and Swanee DiMare Science Village with laboratories, classrooms, and Wings of the Tropics butterfly exhibit, is on location. There are also numerous educational programs and events. Tram tours are available. Fairchild Tropical Botanic Garden is a 501(c)(3) non-profit organization. All photos in this chapter are courtesy of Fairchild Tropical Botanic Garden.

EARLY ON: One of the most famous plant explorers in history was Dr. David Fairchild (1869-1954). An educator and renowned scientist, Fairchild was known for traveling the world in search of useful plants. Fairchild, shown here, plants an African baobab tree *(Adansonia digitata)*, the national tree of Madagascar. The fruit is edible and the leaves are used for medicinal purposes. In 1938, Fairchild Tropical Botanic Garden opened its eighty-three acres to the public for the very first time. The African baobab tree is still growing in the garden by the Gate House, a welcome sight to visitors who come to the gardens.

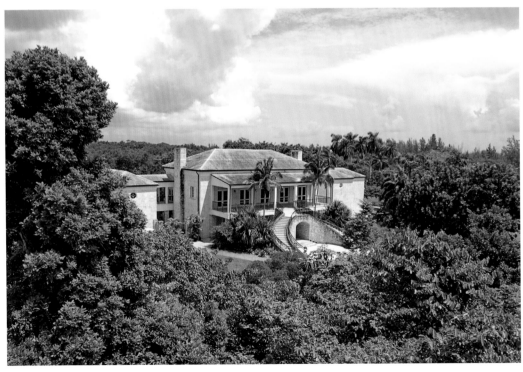

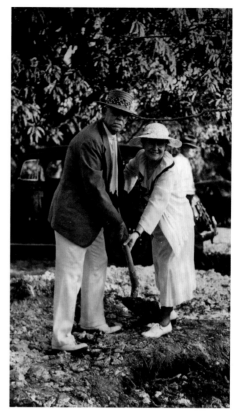

WORLD TRAVELS: Dr. Fairchild was an extensive traveler and brought back many important plants including mangos, alfalfa, nectarines, dates, cotton, soybeans, and bamboos. He also brought back the beautiful flowering cherry trees that Washington, DC, is well known for. Today, the thirty-eight-foot-high indoor Whitman Tropical Fruit Pavilion, built in 2005, is home to many fruit trees, including carambola (also known as starfruit), persimmons, and sapodilla. Adjacent to the pavilion is the Edible Garden, designed to inspire visitors to grow their own foods, and to eat locally. William F. Whitman, whom the pavilion was named after, was a self-taught horticulturalist. Whitman also loved to collect and cultivate rare tropical fruits.

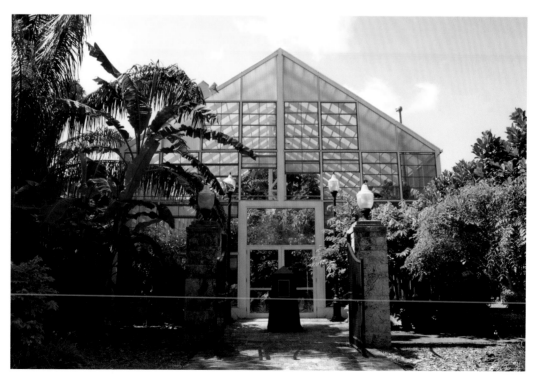

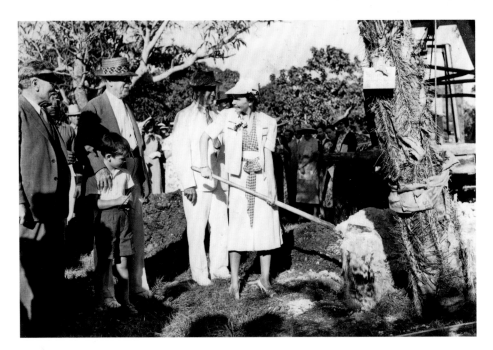

BEAUTIFUL BUTTERFLIES: Colonel Robert H. Montgomery was one of the driving forces behind the Fairchild Tropical Botanic Garden. He was also a local accountant, attorney, and successful businessman, who was passionate about plant collecting. His wife, Nell, is shown here planting a tree. The butterfly exhibit, Wings of the Tropics is located inside of The Clinton Family Conservatory, a 16,400 square-foot conservatory with displays of some 1,900 species of plants. The conservatory is also part of the Paul and Swanee DiMare Science Village, a village that covers more than 25,000 square feet and features five buildings. Besides being beautiful, butterflies are pollinators for flowering plants and trees.

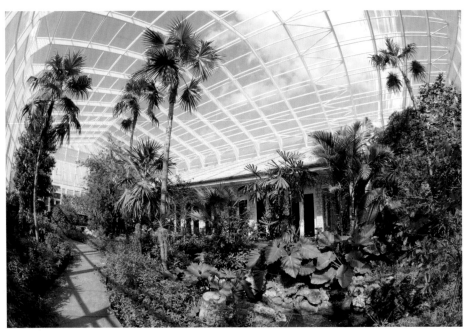

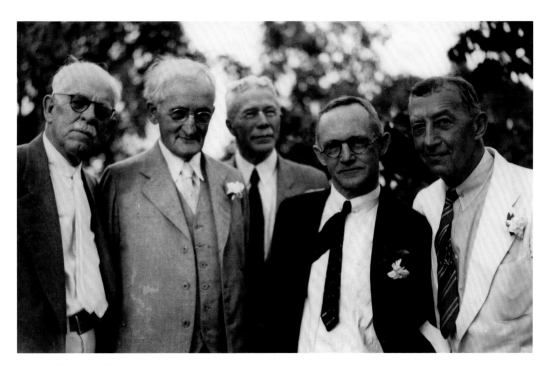

A POPULAR PLACE: The garden was established in 1938, and the dedication took place that very same year, an event that the whole community looked forward to. Shown here are Dr. David Fairchild, Dr. Liberty Hyde Bailey, Dr. Walter Swingle, Dr. Elmer Merrill, and Col. Robert Montgomery (from left to right). Today, guests look forward to the many events that take place at the garden, such as the popular and annual Ramble Festival that offers visitors over twelve acres of plants, garden accessories, antiques, food, music, and plenty of activities.

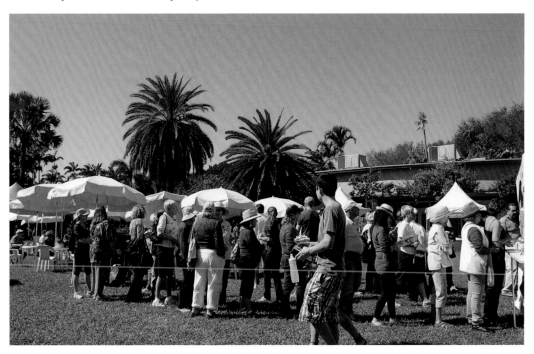

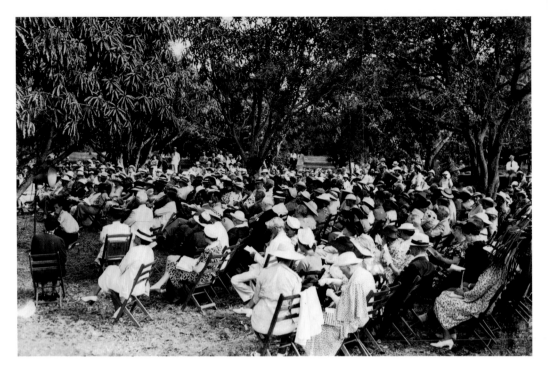

ALWAYS WELCOMING: In 1938, the eighty-three acre Fairchild Tropical Botanic Garden was founded and opened to the public for the first time. The dedication ceremony was a welcome event in the community. Today, the community and visitors from afar enjoy the many events held at the garden, including the Ramble Festival, an annual fall festival with classes, demonstrations, the largest plant sale in all of South Florida, and plenty of family fun, such as the magic show, shown here.

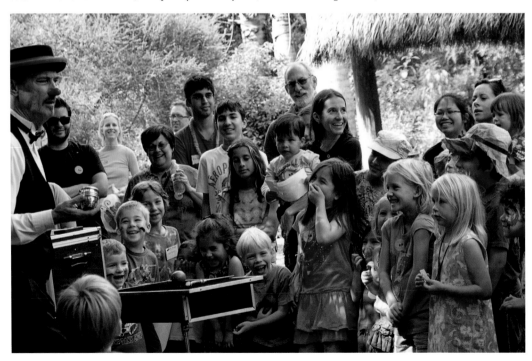

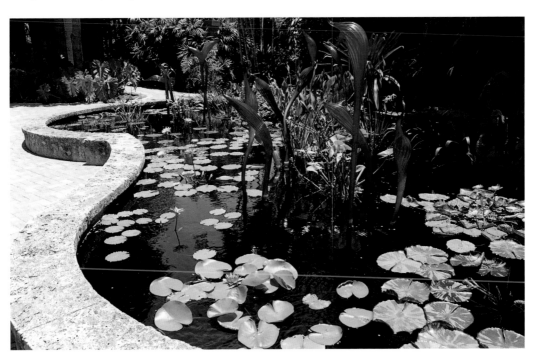

FOUNDERS REMEMBERED: The Founder's Pool is located by the South Gate of the Fairchild Tropical Botanic Garden. The pool was named after Robert H. Montgomery and David Fairchild, founders of the garden. The early image shown here dates to 1960. The Founder's Pool now features large lilies on top of the water. There are blue glass sculptures called, *Blue Herons*, by American artist Dale Chihuly, resting inside of the pool that represent movement. Behind the pool lies tropical vegetation, while the pool also provides a ledge for guests to rest on.

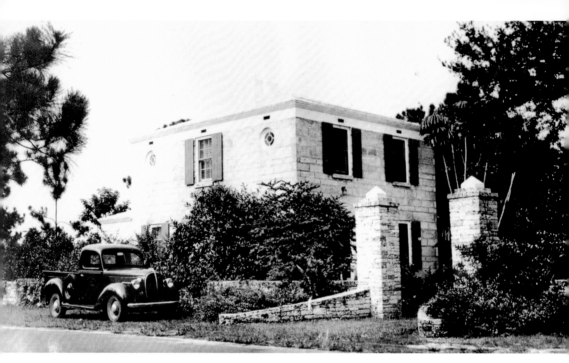

CHANGING ROLES: The 1939 image of the Gate House shows young vegetation surrounding it. The Gate House, an oolite (rock) and wood, two-story structure, was originally the groundskeeper's residence. In 2012, the Gate House, which has become a locally designated historic landmark, was renovated. The vegetation is now markedly larger and more prominent, adding beauty and shade. Today, there is also a Tea Garden available during festivals in the Baobab Courtyard, located right beside the historic Gate House, where guests can enjoy the splendor of this historic building.

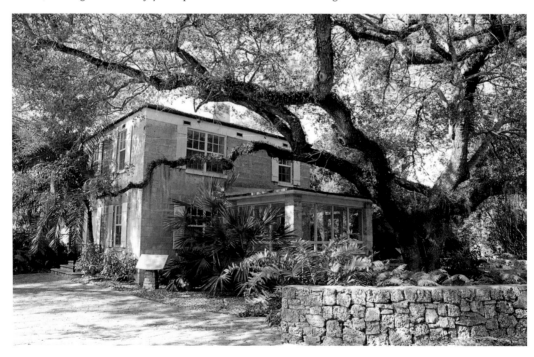

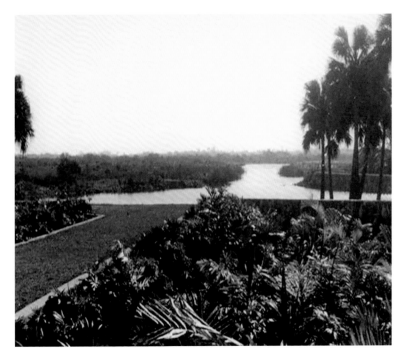

VISIONS REALIZED: The Bailey Palm Glade, along with the Overlook (offering a wide, panoramic view of the Garden's Lowlands), its Allée (a walkway lined with trees and shrubs), and the other elements of design in the Upland portion of the garden, were designed to be an informal treatment, requiring no specific form or character in the vegetation masses. William Lyman Phillips, Fairchild's landscape architect, conceived these portions, along with the rest of the garden. Today, the Bailey Palm Glade offers tall palms and a long, narrow view across the garden's landscape.

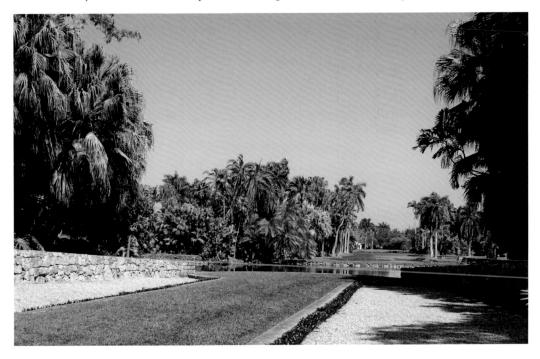

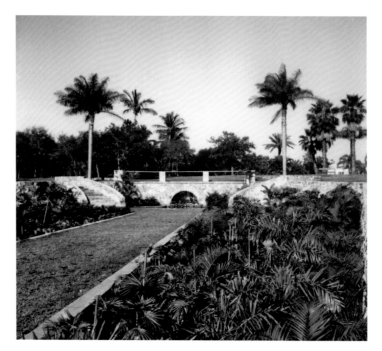

POINTS OF VIEW: William Lyman Phillips, who was born in 1885, in Massachusetts, and obtained his landscape architecture degree from Harvard in 1910, designed The Bailey Palm Glade. In 1938, he contacted Robert Montgomery with ideas for the garden's plans and subsequently became Fairchild's landscape architect. He held this position until 1963, and passed on in 1966. The Palm Glade offers a narrow view of the Garden, while the Overlook offers an even wider one. Together, they provide guests with the opportunity to see the lovely garden at different angles and through different views.

PURPOSEFUL VEGETATION: Dr. David Fairchild planted the African baobab tree in the garden by the Gate House, early on. Fairchild searched worldwide for useful plants and trees that could be eaten or used for medicinal purposes. The baobab trees, often found in Africa, have swollen stems, and inside these stems is where massive amounts of water are stored. The fruits of the tree are large pods called "monkey bread," or "cream of tartar fruit". The fruits are rich in vitamin C. The baobab tree that is located in the garden next to the Gate House now stands at 65′ with a diameter of 103″. A smaller one stands near the Sunken Garden with a diameter of 61″.

WATER ALL AROUND: All told, there are eleven lakes and seven pools at Fairchild Tropical Botanic Garden, allowing for multi-sensory enjoyment by garden guests. The water features at the garden continue to grow and now include the Sunken Garden, Founder's Court, Amphitheater, Victoria Amazonica Pool, Tropical Plant Conservatory, Rare Plant House pools, and the Palm Glade, shown here. The Wings of the Tropics and Simons Rainforest exhibits also have water features.

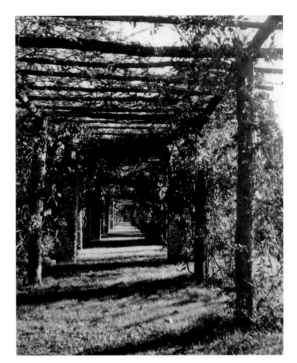

ON THE VINE: On the west side of the garden, next to Old Cutler Road, and adjacent to the Tropical Flowering Tree Arboretum, lays the Vine Pergola, a 560-foot-long historic stone and wood structure. The structure supports a seasonal array of tropical flowering vines in a variety of shapes and beautiful colors, while an inviting walkway sits underneath. The first image shows the structure in 1943, and the later one shows a recent view.

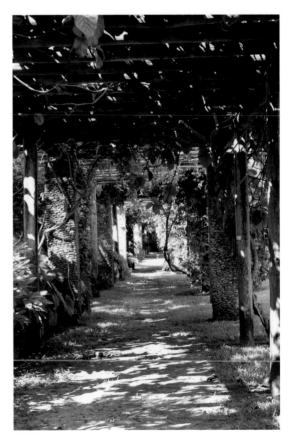

ALL THE FLOWERS: The Tropical Flowering Tree Arboretum offers twelve acres with 740 species of tropical flowering trees, shrubs, and vines that were collected from various tropical regions of the world. They are arranged by plant family and show off the diversity of form, structure, texture, color, and fragrance. The early picture shows young plantings, terraces, and grading, while the newer image shows how the plants fill in the space.

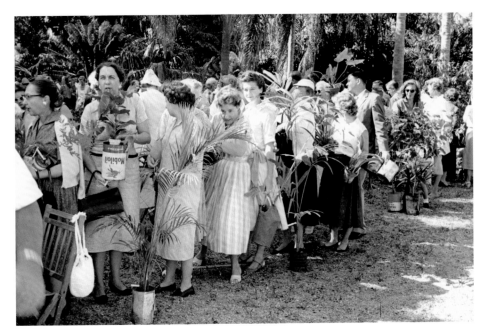

MEMBERS' PLANT SALE: Fairchild held the first Members' Plant Distribution in April 1939. Thirty-seven species of palms and thirty-one species of trees, shrubs, and vines were ready for purchase by members. Today, most of the plants offered for sale are propagated from plants growing in the garden or from the gardens of staff or volunteers. Plants that are distribution plants are grown in larger quantities, and are described and photographed in the Members' Day Plant Sale brochure. Sale plants are considered plants in smaller quantities and are not found in the brochure. The sale has been popular throughout the years as shown in this 1958 photo, and the more recent one. Members have always been encouraged to arrive to the sale early as the plants sell out fast at this long-time popular annual event.

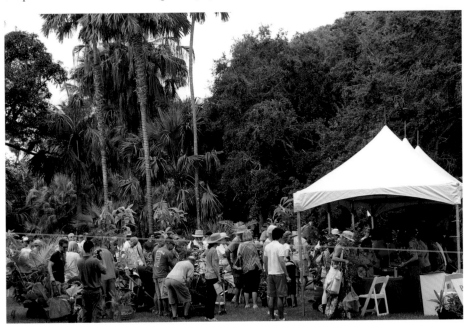

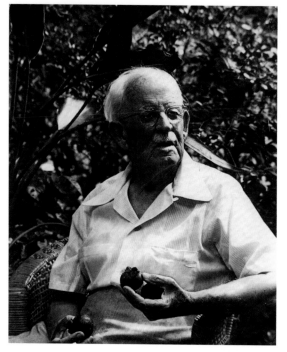

FESTIVALS AND EVENTS: Many of the early operations were completed by a small group of people, including Dr. David Fairchild, shown here, surveying a tropical fruit. Today there are approximately 1,200 volunteers who help assist with the garden's day-to-day operations and special events, such as the annual International Chocolate Festival where visitors can learn about the cycle of a cacao plant, and sample fine chocolates from artisan chocolatiers. They can also hear lectures on chocolate making and watch demonstrations from Miami's master chefs and chocolatiers.

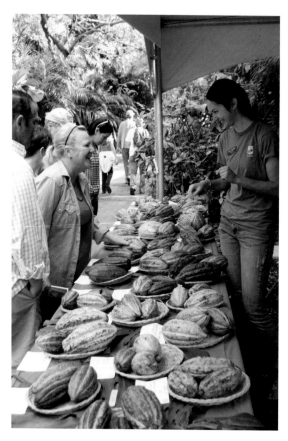

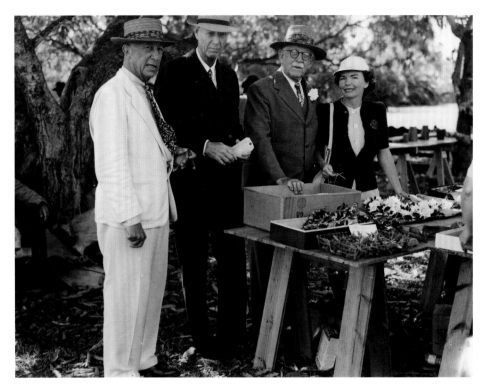

UNDER THE MICROSCOPE: From left to right is Col. Robert Montgomery, David Fairchild, and Nell Montgomery, and an unidentified gentleman in a black suit. Today the Hsiao Laboratories houses four themed labs: The Micropropagation Lab, equipped for propagating and growing plants under sterile conditions; the Jason Vollmer Lab that processes incoming pupae from butterfly farms throughout the world; the Baddour DNA Laboratory, a working and teaching space focused on plant genetic studies; and the Imaging Laboratory that includes high-powered light microscopes and digital photography equipment for botanical and entomological study. All labs ultimately work to preserve the biological diversity of the tropical world.

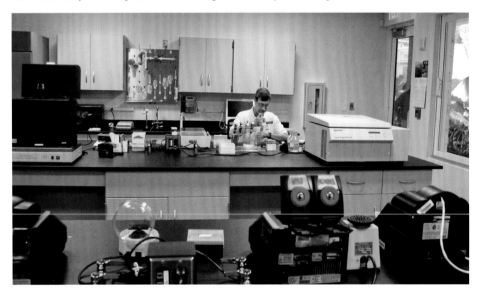

EXPLORATION AND DISCOVERY:
On the 1939 Cheng Ho expedition, there were nine participants. They were from the United States, the Netherlands, and Great Britain. There were also ten crewmembers, including Dr. David Fairchild who was in his seventies at the time but was still a highly respected plant expert and collector. The intention of the trip was to find new plants and places to send seeds for cultivation. On the six-month expedition to the Philippines, and the Indonesian Archipelago, there were more than 500 different kinds of plants that were collected and shipped to the garden. This included the ninety species of palms, along with many shade and ornamental trees, as well as numerous vines. Today, the Paul and Swanee DiMare Science Village at Fairchild offers scientific exploration and discovery for all ages. The Science Village also works to preserve and inspire nature lovers and future generations of scientists.

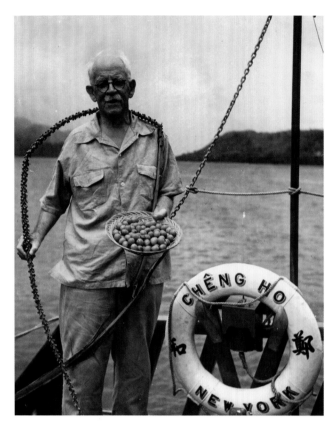

FLAMINGO GARDENS, DAVIE

Founded as a botanical garden in 1927

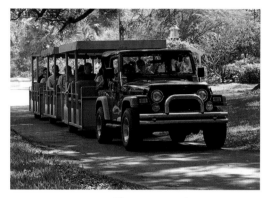

Photo courtesy of Lorenzo Cassina.

In 1925, Floyd L. and Jane Wray came to Florida. One year later, they purchased 320 acres of drained swampland, including Long Key in the Everglades. On January 2, 1927, Floyd incorporated Flamingo Groves, the first step in becoming one of the area's first botanical gardens and tourist attractions. That same year, Floyd, and his business partner Frank Stirling, planted the first citrus tree. Twenty acres were set aside as a citrus laboratory and a showcase botanical garden. Throughout the 1930s, exotic trees, plants, and seeds were brought in from worldwide botanical gardens and collectors through the US Department of Agriculture's foreign plant introduction. They still make up the core of the botanical collection today. Peacocks and alligators were later added to the groves. In 1969, in honor of her late husband, Jane Wray established a non-profit foundation to maintain the property, which subsequently changed the name to Flamingo Gardens. In 1990, the Everglades Wildlife Sanctuary opened with the Bird of Prey Center, a sanctuary for injured or non-releasable native wildlife. Soon after a half-acre Free-Flight Aviary was opened, as well as wildlife habitats for Bald & Golden Eagles, river otters, bobcats, tortoises, and Florida panthers. This nonprofit 501(c)(3) now offers one of the last natural jungle growths in South Florida. There are over 3,000 tropical and subtropical species of plants and trees, including the largest tree in Florida, the largest single collection of State Champion trees, over six-dozen peacocks, fifteen flamingos, over ninety species of native birds and animals, and the largest collection of Florida wading birds. There are also wildlife encounters, ecological tours, and special events. The property is a Broward Cultural Heritage Landmark, and the Wray Home is a registered Florida Historical Landmark. All historic photos in this chapter are courtesy of Flamingo Gardens.

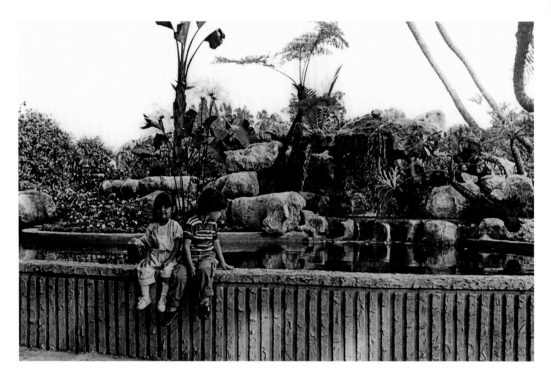

COLOR AND MOVEMENT: The koi pond was originally opened in 1989, as a turtle pond, and as part of the Butterfly Garden. The pond now holds colorful koi and goldfish. Koi come in bright colors such as black, white, yellow, and red, while goldfish are generally bright orange in color. Other differences between the two are that goldfish are rounder and grow to about ten inches in length, whereas koi are more streamlined and grow to about twice that length. *Photo courtesy of Lorenzo Cassina.*

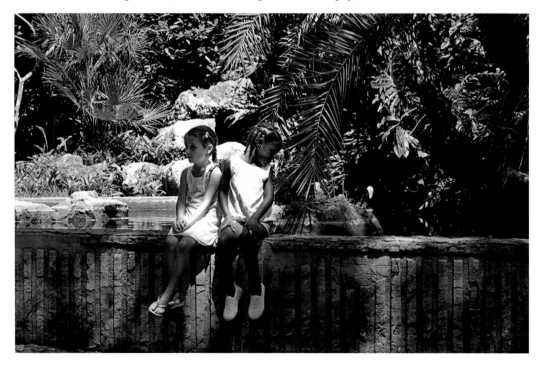

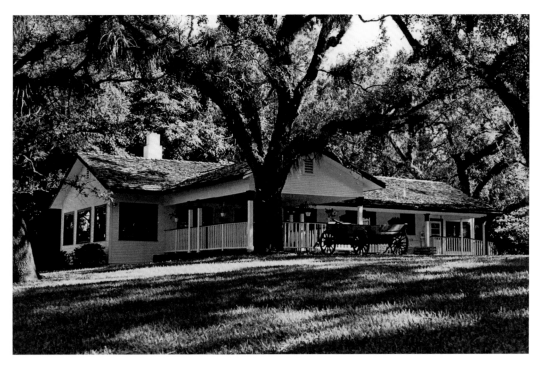

AN EARLY RETREAT: The Wray Home was built in 1933, as a weekend retreat for Floyd L. Wray and his wife, Jane. The home has been restored and is now a museum that offers visitors a glimpse of life in South Florida in the 1930s. Inside there is kitchen, a dining room, two bedrooms, and a sunroom. It is the oldest residence in Broward County, west of University Drive. Guided tours by Wray Home are available. (Photos: *circa* late 1980s and 2015.) *Photo courtesy of Lorenzo Cassina.*

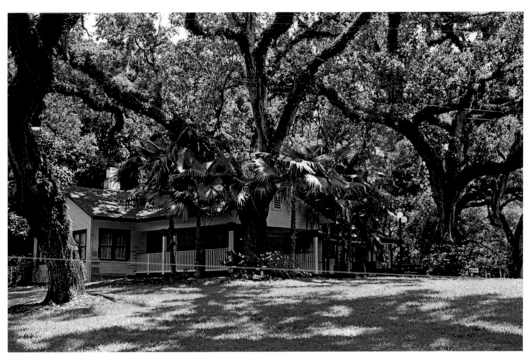

BLOOMING BEAUTIES: The Amaryllis Garden opened in 1989, and the Wedding Gazebo was added in the early 1990s. It is now the site of many weddings and special occasion ceremonies. Amaryllis are subtropical plants that boast trumpet-shaped flowers, and whose blooms grow up to six inches across. The flower color ranges from reds to oranges to pinks to pure white, while others are striped and multi-colored. Theses beautiful flowers make an exquisite backdrop for a wedding day. (Photos: 1989 and 2015.) *Photo courtesy of Lorenzo Cassina.*

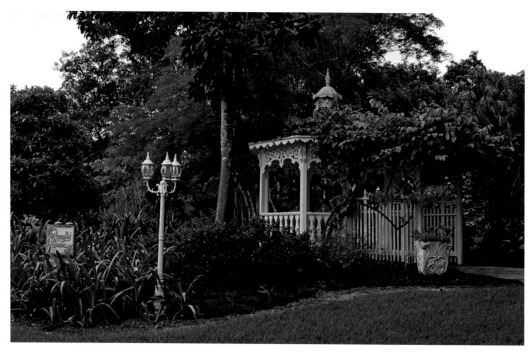

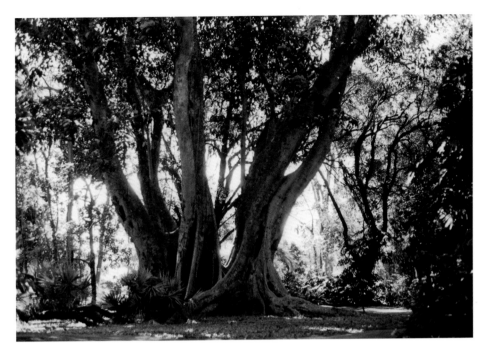

A TALL TREE: The on-site cluster fig (*Ficus racemosa*) was designated a Florida Champion tree of its species in 1983. It was originally planted in the 1930s. Today the tree is the largest single trunk tree in Florida. The American Forests conservation organization created the Champion Tree Program in 1940, as a way to recognize the largest known tree of each species in the United States. Every two years the organization publishes their National Register of Big Trees; currently, Florida has more national champions than any state, and Flamingo Gardens has eighteen total. (Photos: Early 1960s and 2015.) *Photo courtesy of Lorenzo Cassina.*

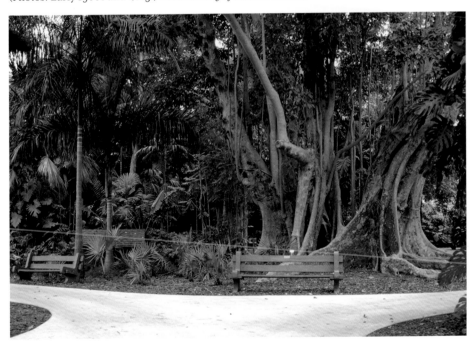

THE TRAFFIC FLOWS: Traffic first entered directly off Flamingo Road. However, in the mid-1990s, both parking and the main entry were moved to the north side of the gardens. Today, many guests come to enjoy the Botanical Gardens & Everglades Wildlife Sanctuary, while others come on class field trips to attend events and activities. Still, others come to get married in the Amaryllis Garden. (Photos: Mid-1990s and 2015.) *Photo courtesy of Lorenzo Cassina.*

WILD WETLANDS: The Mitigated Wetlands originated from a lake that was dug out for gravel in the mid-1970s. The 1.6 acres of wetlands were created in 1989. Except for the steeply-sloped middle, most of the Wetlands is three-feet-deep with shallow margins. The purpose of mitigated wetlands is to replace lost wetland resources with those that have been created or restored. The goal is to replace what was lost as fully as possible. (Photos: 1989 and 2015.) *Photo courtesy of Lorenzo Cassina.*

BLUE AND GREEN: Wetlands are areas that are saturated with water and often full of aquatic plants. The Wetlands at Flamingo Gardens are not only a habitat for aquatic animals, fish, and turtles, they offer visitors a view of serene waters. Surrounding the wetlands is natural vegetation that grows in abundance and makes for a lovely backdrop. (Photos: 1989 and 2015.) *Photo courtesy of Lorenzo Cassina.*

A PLACE AND A PURPOSE: The Wetlands area is now an important part of Flamingo Gardens' wildlife and educational programming. The area is used to release rehabilitated wildlife and young born in the wildlife sanctuary. It is also the site of the garden's "Save Our Swamps" educational program designed for students and summer programs. (Photos: 1989 and 2015.) *Photo courtesy of Lorenzo Cassina.*

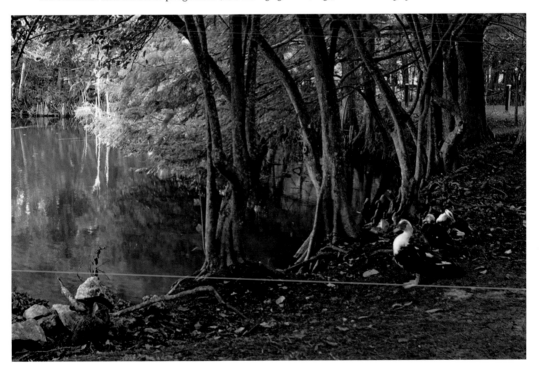

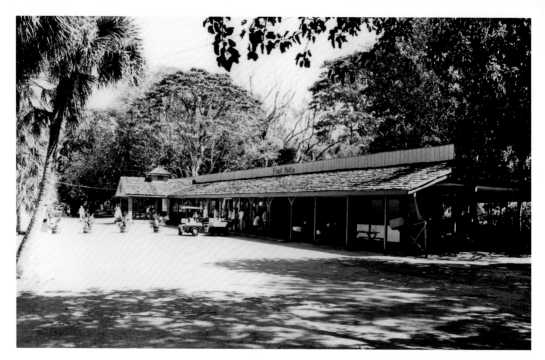

CITRUS TO SMOOTHIES: When the gardens first opened, visitors passed through a citrus fruit shipping and open-air marketplace. Citrus canker and disease have since eliminated nearly all of the orange and citrus trees on the property. The property originally had a citrus grove of more than sixty varieties, which later grew into 2,000 acres, including a twenty-acre citrus laboratory. The marketplace has been renovated to contain an office space and a tropical smoothie bar. (Photos: Late 1980s and 2015.) *Photo courtesy of Lorenzo Cassina.*

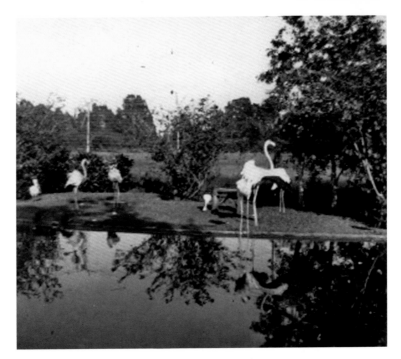

COLORFUL AND POPULAR: Legend has it that flamingos were found nesting on the property when Floyd L. Wray and his wife, Jane, bought the property in 1926. Jane introduced peacocks and the first Flamingo Pond in the 1940s, to the delight of visitors. The long-legged flamingos with their bright red, pink, or orange colors are a colorful favorite, as are the peacocks with their elaborate and colorful trains. Today, other wading birds, like white ibis, also find their home in the pond. (Photos: 1955 and 2015.) *Photo courtesy of Lorenzo Cassina.*

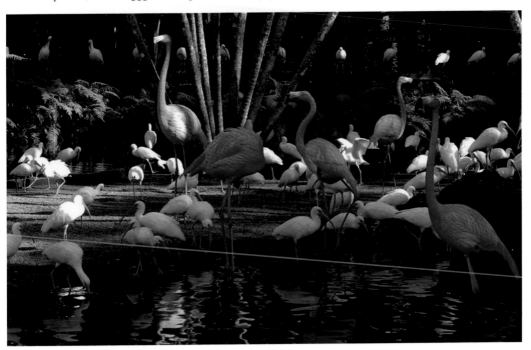

BRIGHT AND BEAUTIFUL: Today, the Flamingo Pond is home to fifteen Caribbean Flamingos. They are the only flamingo to naturally inhabit North America, and are the brightest of all the flamingo species. They make a loud honking call that sounds similar to a goose. They also sweep their curved bills upside down through shallow water to pick up food as they stroll along. Caribbean Flamingos live and breed in colonies, so they are best in a crowd. (Photos: 1962 and 2015.) *Photo courtesy of Lorenzo Cassina.*

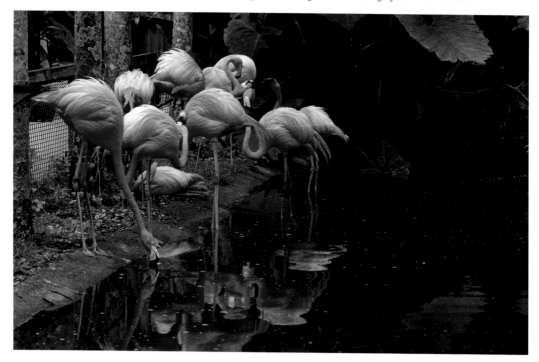

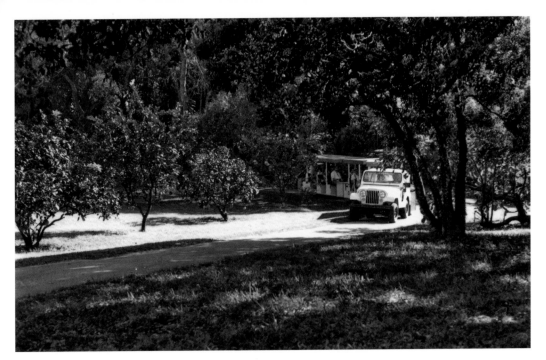

TRIP ON THE TRAM: In the beginning, walking tours of the citrus groves and botanical garden were offered. It is thought that the tram tour was introduced in the late 1940s or early 1950s. The complimentary twenty-five-minute Tram Tours offer guests an open-air narrated ride across forty-two acres that includes a ride through a unique native hammock of 200-year-old live oaks with flowering plants, a tropical rainforest, and tropical fruit groves. Guests aboard the tram may disembark at certain points to walk or wander and see the wildlife. (Photos: 1980s and 2015.) *Photo courtesy of Lorenzo Cassina.*

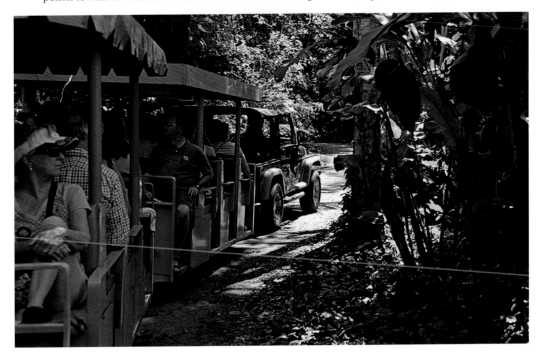

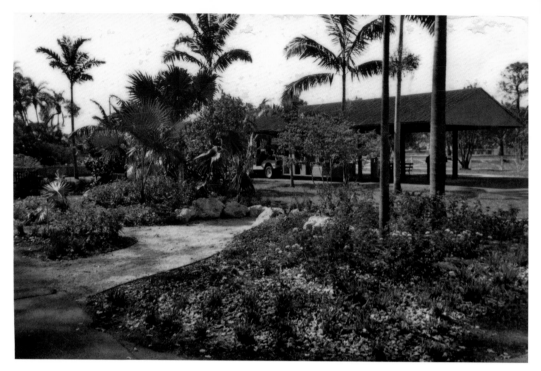

STARTING AT THE STATION: The Tram Station was built in 1989, and remains much the same today. A Tram Tour allows guests to enjoy the open-air experience of the gardens, rainforest, and groves. A tour leaves from the station every thirty minutes on the hour, and on the half-hour, from 11:00 a.m. to 4:00 p.m. (Photos: 1989 and 2015.) *Photo courtesy of Lorenzo Cassina.*

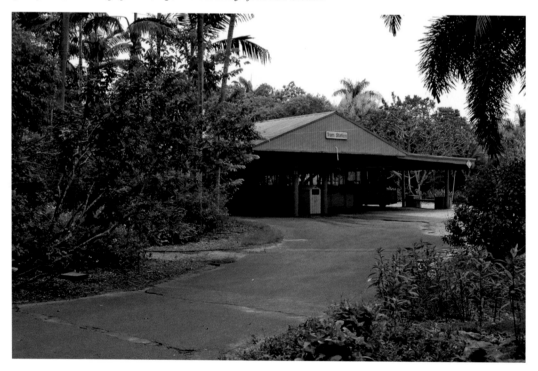

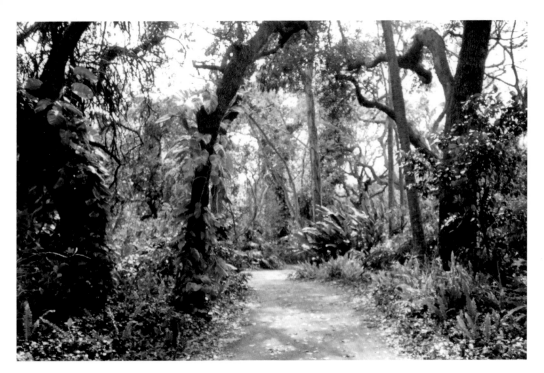

THE TRAM TRAIL: Five acres of the Tram Trail have been left untouched to grow naturally, so it appears similar to how it was many years ago when the Seminole Tribe inhabited the hammock. The Tram Tour offers visitors a chance to disembark the tram while at the Wetlands Walkway, so they can walk around the lake and see the wildlife. They can also disembark at the Pioneer Walkway, where they can discover native Florida plants. (Photos: Early 1990s and 2015.) *Photo courtesy of Lorenzo Cassina.*

HOME AND GARDEN: The Wray home was originally built in 1933 as a weekend retreat for Floyd L. Wray and his wife, Jane. The home has a beautiful lawn in the front yard. Although the home is now a museum, the lawn is much the same as it ever was with flourishing vegetation. (Photos: Late 1980s and 2015.) *Photo courtesy of Lorenzo Cassina.*

A MEAL AND A VIEW: The Flamingo Pond was expanded in 1989, and the Flamingo Cafe opened in the early 1990s. The Flamingo Cafe is open seven-days-a-week and offers freshly-made sandwiches, salads, snacks, and drinks. Since the Café offers outdoor seating that has the Flamingo Pond on one side, and the Butterfly Garden, the Hummingbird Garden, and the Wildflower Garden (with wildflowers that are native to South Florida), on the other side, one can enjoy their meal in a blissful sanctuary. The Ruby Throat Hummingbird often pays a visit during the winter months. (Photos: 1989 and 2015.) *Photo courtesy of Lorenzo Cassina.*

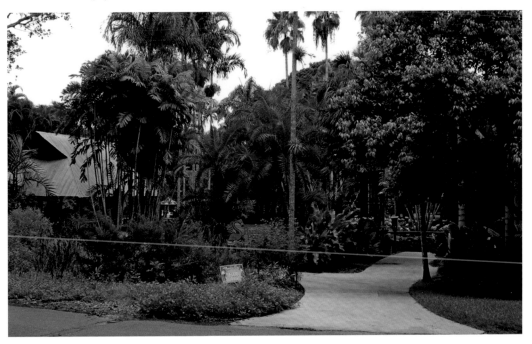

BIRDS OF A FEATHER: The Everglades Wildlife Sanctuary, located in the gardens, opened in 1990. The 25,000 square foot Free-Flight Aviary opened in 1991, and was one of the first of its kind, offering residence to injured wading birds. It now houses over 200 birds representing over forty-five species, as well as one of the largest collections of wading birds in America. The five unique ecosystems of the Florida Everglades – coastal prairie, mangrove swamp, cypress forest, subtropical hardwood hammock, and sawgrass prairie – are represented in the aviary. (Photos: 1990 and 2015.) *Photo courtesy of Lorenzo Cassina.*

NAPLES ZOO AT CARIBBEAN GARDENS, NAPLES

Founded as a botanical garden in 1919

In 1919, botanist and early conservationist Dr. Henry Nehrling, acquired the Naples site to house and help protect his plants, and to found his botanical garden. By 1925, Nehrling had collected about 3,000 species of tropical plants. Leading scientists and environmentalists came for visits and for consultation, including Theodore Roosevelt, John Burroughs, Liberty Hyde Bailey, Charles Torrey Simpson, David Fairchild, and Thomas Edison. While working for the Office of Foreign Seed and Plant Introduction to the US Bureau of Plant Industry, Nehrling introduced to the United States the colorful caladium, along with over 300 new and beneficial plants. Upon his death in 1929, more than twenty years passed before his garden was once again admired. In 1952, Julius Fleischmann began the immense

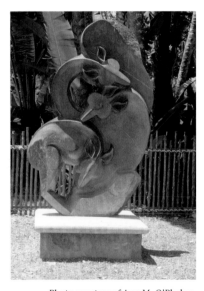

Photo courtesy of Ann M. O'Phelan.

restoration of Nehrling's garden. He cleared a trail, removed debris, nurtured old plantings, dug lakes, and planted new species. In 1954, the gardens, then called Caribbean Gardens, were filled with tropical birds and were opened to the public. In 1969, thanks to Lawrence and Nancy Jane Tetzlaff, who were expedition leaders and zoo operators in the Midwest, the gardens added a zoo: Naples Zoo. In 2004, the land was purchased by Collier County, and transitioned into a nonprofit entity, 501(c)(3), that is funded by donors, visitors, and members. Today, the Naples Zoo offers a wide range of exhibits, such as a primate expedition cruise, a chance to meet the zookeeper, and the opportunity to hand-feed creatures and enjoy a live show in the Safari Canyon – all set inside of the beautiful botanical gardens that were originally planted by Nehrling. Also offered is a gift shop, and Wynn's Market for healthy food and drinks. All historic photos in this chapter are courtesy of Naples Zoo at Caribbean Gardens.

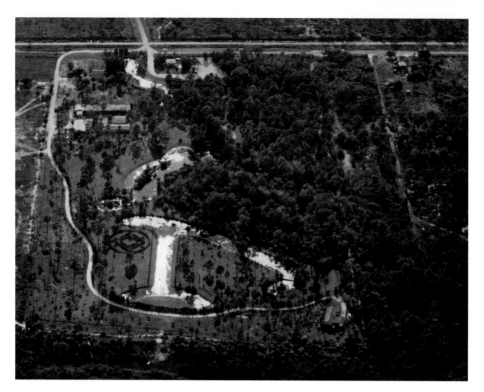

WELCOMING SIGHT: This early aerial shot of the zoo shows the original pathways, the thick tropical vegetation, and the general layout. Today's welcome center also offers information and zoo maps, while the Zoo Gift Shop offers a variety of wildlife-related gifts, toys, books, and attire. The design of the 1950s-style welcome center sign gives a nod to the zoo's original inception date of 1954, when it was first called Caribbean Gardens. *Photo courtesy of Ann M. O'Phelan.*

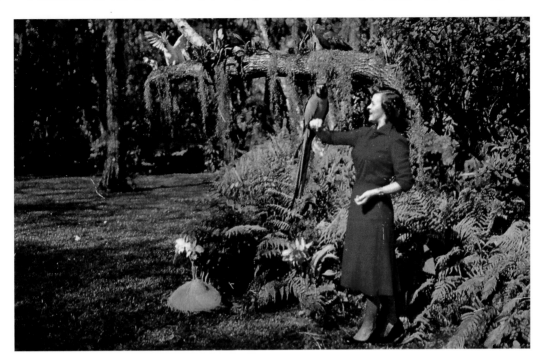

BRIGHT AND BLENDING: Due to their vivid colors, larger beaks, and long tails, macaws are hard not to spot, unless, of course, they are in their native tropical forests where they can blend in with the colorful flowers and other vegetation. A variety of birds have always been a delightful aspect of the Naples Zoo, as they are part of the exhibits and programs where guests can not only see them but they can cay also learn more about their mannerisms, habitats, and diets. The zoo also attracts its share of wild birds, such as the white ibis, that also enjoy the lush tropical setting and water features, including Lake Victoria, Cypress Hammock, and Alligator Bay. *Photo courtesy of Ann M. O'Phelan.*

PAVED PARADISE: Back when the zoo first opened in 1954, the parking lot was unpaved and was much smaller than it is today. That's because the zoo now draws about 360,000 or more visitors each year, so more parking is required. These days, the parking lot is paved, however, there are a variety of marked and gravel walkways throughout the park as they are easy to navigate and fit well into the natural tropical settings. All told, there are about 0.8 miles of walking trails that are also navigable by wheelchairs. *Photo courtesy of Ann M. O'Phelan.*

A LOVELY LINE: The royal palm *(Roystonea oleracea)*, is a large, majestic palm that is found in both Cuba and Southern Florida. The height reaches up to seventy feet, and the branch spread is up to twenty-five feet across. Royal palms are often found lining notable streets and driveways as they make a tall statement, especially when lined up n a row. Dr. Henry Nehrling planted some of the royal palms at the Naples Zoo at Caribbean Gardens. Julius Fleischmann planted the Main Palm Walkway along the zoo's main path and on islands, which later became islands on Lake Victoria where primates now live. These days, guests to the zoo and gardens enjoy seeing the royal palms and primates on a 15-20 minute primate expedition cruise that is offered several times a day aboard an open-air catamaran. *Photo courtesy of Ann M. O'Phelan.*

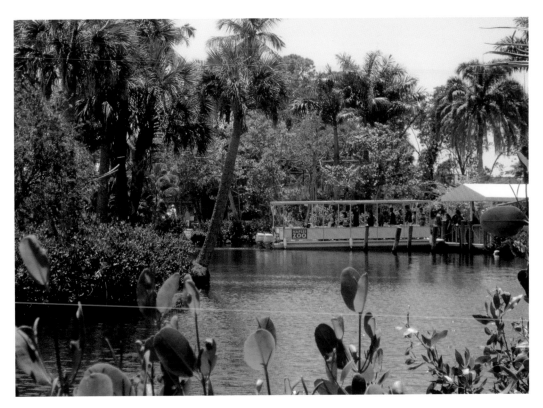

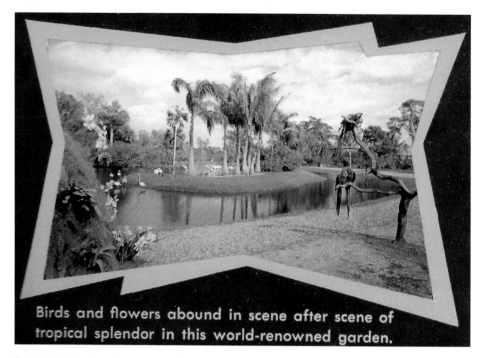

Birds and flowers abound in scene after scene of tropical splendor in this world-renowned garden.

ISLAND LIFE: Even from the very beginning, the colorful birds and inviting waterways were a source of pride for the zoo. Although wild birds sometimes make their way onto the islands on Lake Victoria, they are actually the homes of a variety of primates, such as the brown lemur from Madagascar, the black-handed spider monkey from tropical rainforests, and the Southeast Asian buff-cheeked gibbon. *Photo courtesy of Ann M. O'Phelan.*

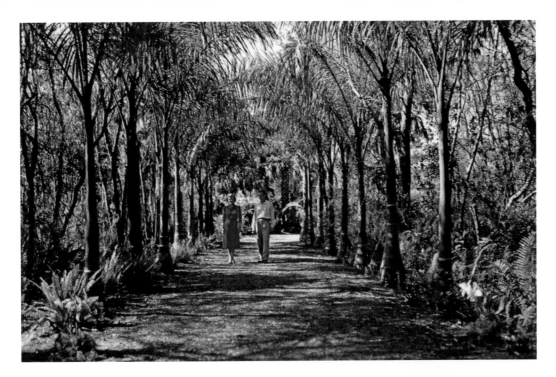

FINDING THE WAY:
Numerous trails meander through the zoo and gardens in circular looping patterns. Some of the trails are lined with tropical trees, such as with this example of the royal palms. Other trails are lined with trees, plants, and other vegetation that are all part of the 3,000 species that can be found. Also on the trails are markers pointing out directions and explaining the rules. *Photo courtesy of Ann M. O'Phelan.*

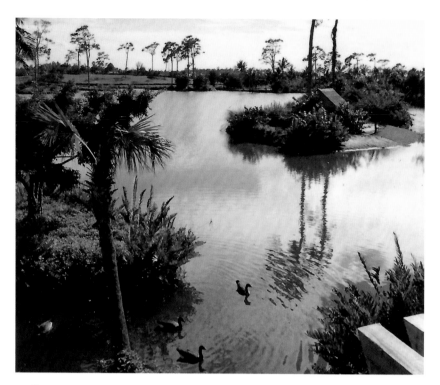

BY THE LAKE: Although in the early days, Lake Victoria, the lake that surrounds the primate islands, had some vegetation, the lake's surrounding vegetation has since grown in densely. Nowadays, the shade at the Look Out Point provides an oasis for guests to sit nearby the water and enjoy the atmosphere as they watch the primate cruises pass by. *Photo courtesy of Ann M. O'Phelan.*

ENJOY THE VIEW: The waters and lagoons have long been enjoyed by visitors who could get up close to them at Lake Victoria, Cypress Hammock (shown here), and Alligator Bay, which is fenced. These days, guests can still enjoy an even closer look through a viewfinder at Lake Victoria. *Photo courtesy of Ann M. O'Phelan.*

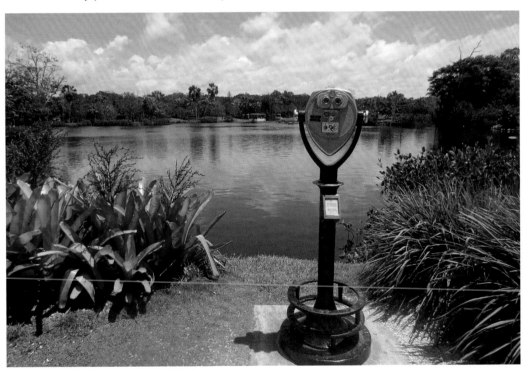

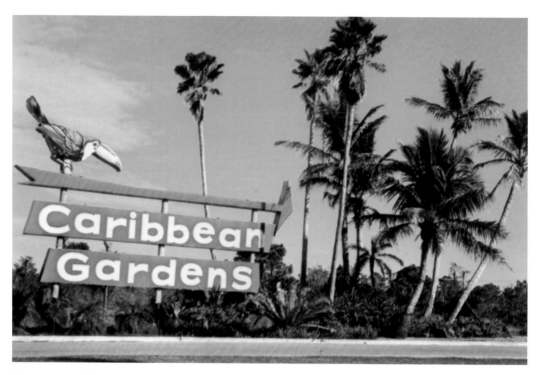

SIGNS OF THE TIMES: In 1954, the Naples Zoo was called Caribbean Gardens, and the big, bold sign on the outside pointed people in the direction of where to go. These days, there are many signs that point out the main attractions, such as to the lion exhibit, the tiger exhibit, the Florida panther exhibit, the Backyard Wildlife Habitat, and the Rainforest Grove. *Photo courtesy of Ann M. O'Phelan.*

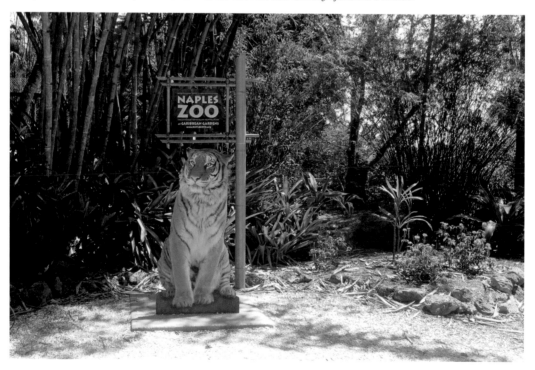

UP CLOSE AND PERSONAL: Enjoying up close and personal experiences with animals has long been part of the attraction of the Naples Zoo at Caribbean Gardens. Today's guests can still enjoy a wide range of animal exhibits–from birds to mammals to reptiles. Plus, they can also enjoy a variety of animal encounters and animal programs, along with Meet the Keeper, and the Safari Canyon Open-Air Theater. *Photo courtesy of Ann M. O'Phelan.*

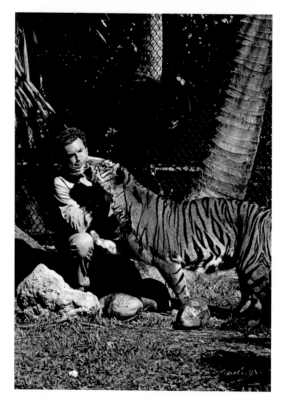

THE BIG CATS: Malayan Tigers are originally from the Malay Peninsula and are considered critically endangered. In fact, there are only about 250-340 of them left in the wild. These lovely big cats are a beautiful orange with black stripes and white around the face. They have always been a big attraction at the zoo, when Larry Tetzlaff, also known as Jungle Larry, was around. Tetzlaff was the one who originally brought his beloved animals to the Caribbean Gardens in 1969, which later became known as Naples Zoo at Caribbean Gardens. *Photo courtesy of Ann M. O'Phelan.*

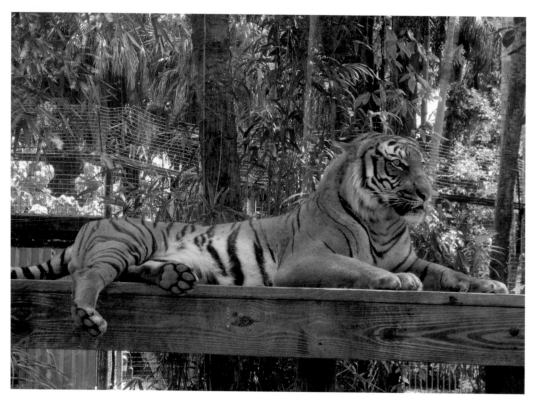

Peaceful river passing the Chimpanzee Island. Exotic water-fowl join the chimps at feeding time.

HANGING AROUND: The primates that reside on the eight primate islands have long enjoyed a peaceful setting where they were offered protection from predators and a beautiful view. They still enjoy an island view, as well as homes where they can come and go as desired, and that offer plenty of outdoor ropes on which to hang and sway. *Photo courtesy of Ann M. O'Phelan.*

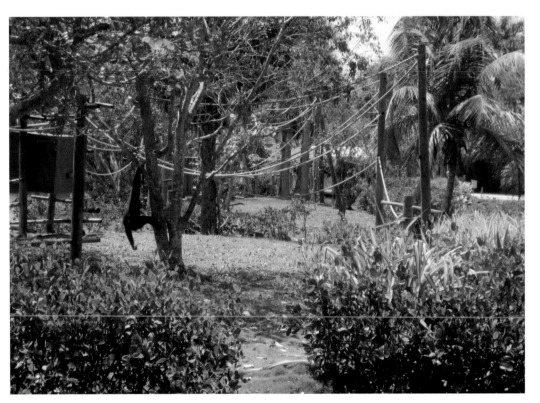

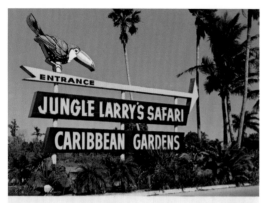

Naples-On-The-Gulf Florida

"THE NAME OF THE GAME IS CONSERVATION"

Let us be concerned with the conservation of the world's animals. Within one year 89 species of fish, birds and mammals have become extinct. 150 more are endangered. These are part of our common heritage. We must understand them, protect and preserve them!

The Board of Directors, Officers and Staff of JUNGLE LARRY'S SAFARI LAND, INC. are all dedicated to preserving and breeding many of the world's rarest animals.

Lawrence E. Tetzlaff
PRESIDENT

CONSERVATION EFFORTS: Since it's inception the Naples Zoo at Caribbean Gardens' focus was on conservation, as was the vision of the founder, botanist, and early conservationist, Dr. Henry Nehrling. The Naples Zoo is ranked as one of the top zoos in the nation contributing to field conservation as a percentage of total budget. The zoo also has a variety of conservation programs that they are involved in on a worldwide basis, such as Giraffe Conservation Foundation, and the Madagascar Fauna and Flora Group. Since 2009, The Naples Zoo has helped plant over half a million trees in their efforts with another non-governmental organization. *Photo courtesy of Ann M. O'Phelan.*

KID FRIENDLY: Thanks to the picturesque grounds, the variety of wild animals, and numerous programs, kids have always enjoyed coming to the zoo and gardens. The zoo is still a great a place for them to enjoy family programs, camps, field trips. The memory of a day at the zoo always leaves a wonderful imprint. *Photo courtesy of Ann M. O'Phelan.*

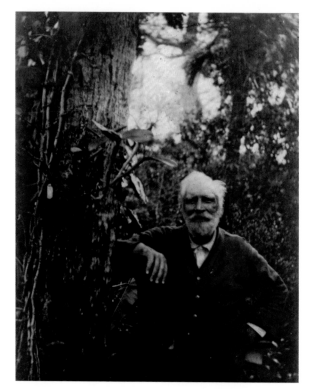

TREE SIZES: Botanist and early conservationist, Dr. Henry Nehrling, stands beside a large tree. Trees grow in a variety of sizes and shapes. Some trees are as small as bushes and may actually look like shrubs, while others grow to impressive heights, such as the California Redwood (*Sequoia sempervirens*), that grows hundreds of feet tall. Other trees, such as the Geiger tree *(Cordia sebestena),* are considered medium-sized and can grow to twenty-five feet tall. The Geiger tree is a flowering tree that has showy, yellow-orange, trumpet-shaped flowers, each with six petals. *Photo courtesy of Ann M. O'Phelan.*

BLOOMING AND BLOSSOMING: Nehrling acquired the Naples site in 1919, in order to house and help protect his plants, and to found his botanical garden. Nehrling previously worked for the Office of Foreign Seed and Plant Introduction to the US Bureau of Plant Industry. He actually introduced over 300 new and beneficial plants to the United States, including the caladium. Today, the forty-three-acre zoo and gardens bloom with a variety of botanical exhibits, many with colorful flowers. *Photo courtesy of Ann M. O'Phelan.*

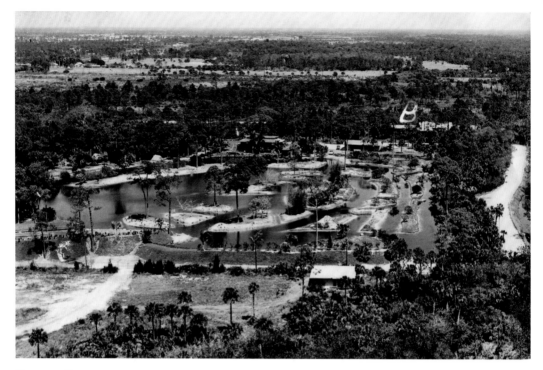

PICTURE PERFECT: This early aerial view of the zoo and gardens shows the many waterways and vegetation plots. Since the early days, the gardens have filled in with more and more plants, a large variety of exotic animals, and guests from around the world who enjoy wandering through the trails that blend the beautiful botany with the exotic zoo animals. *Photo courtesy of Ann M. O'Phelan.*

LAKES PARK BOTANIC GARDEN, FORT MYERS

Founded as a botanical garden in 1994

T ucked on the northeast corner of Lakes Park lies the Botanic Garden at Lakes Park. The 501(c)(3) garden is nestled within the park's parameters. Lakes Park offers everything from numerous lakes to paved and ADA-accessible hiking trails; from playgrounds to healthy workout stations; from kayaking to non-motorized boat rentals; and it even has a railroad museum with a miniature train that makes its way through the park. Lakes Park is owned and operated by Lee County Parks & Recreation and draws one million visitors per year. The eighteen-acre botanical garden, which is still under development, is just steps away from these many outdoor activities. Once in the garden, visitors can enjoy a series of garden rooms with signed plant collections, including a heritage rose

Photo courtesy of Ann M. O'Phelan.

garden, a vertical garden, a water garden, a ginger garden, a butterfly garden, and vestiges of the old fragrance garden. There's even a lovely white wedding gazebo for celebrations, and a World Peace Circle for guests to rest and reflect in. Markers help guests identify wildlife and butterflies that are found in abundance. Although the garden is on the park's property, it is maintained by a dedicated group of volunteers. Lakes Park Enrichment Foundation, a fundraising arm for the park, has added funds to the gardens. The Foundation's next project will be to build a children's garden to teach youngsters and their parents about the wonders of plants and how necessary plants are to life on earth. The children's garden construction has started and will continue the next few years. Those who love to garden themselves can partake in the nearby community garden with 4' x 8' plots. The first expansion of the garden was in 2006, when the community garden was added. Today, the seventy-five garden beds are rented on an annual basis. The gardeners enjoy learning to garden their own plots, while participating in the active garden community. Tours of the botanic garden, tours of the fragrance garden, demonstrations, and events are also offered. All historic photos in this chapter are courtesy of Lakes Park Botanic Garden.

SWEET SMELLING: Fragrance gardens not only delight the eye, they ignite the sense of smell. Pleasant smells have been long known to lift spirits and energy, and add to one's sense of enjoyment. The Fragrance Garden, filled with roses, gardenias, and lilies, was added in the first phase of the garden's creation and has been blossoming ever since. *Photo courtesy of Ann M. O'Phelan.*

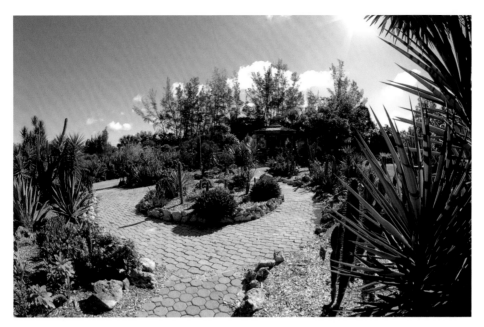

RICH SUCCULENTS: Dick McConille planned The Succulent Garden in 1994. Succulents store water in their leaves and trunks in order to help them survive in desert or semi-desert areas. Succulents have thick leaves and spiny trunks to ward off desert animals looking for water. The succulent specimens, including cactus, agave, euphorbias, are all large and well developed. When plotting the garden, several boulders were in the way; however, thanks to funding from the North Fort Myers Rotary Club and helpful Rotarians, the earth and rocks were moved to make way. Plants were donated from the UF Master Gardeners, neighbors and other interested parties. Leftover bricks from road projects were used to line the path. The site is also built up to assure proper drainage, while the many limestone boulders from the original quarry add distinctive Florida flavor. *Photo courtesy of Ann M. O'Phelan.*

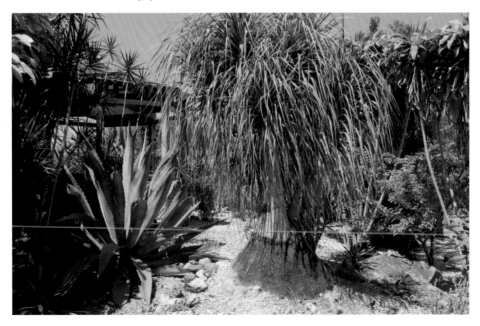

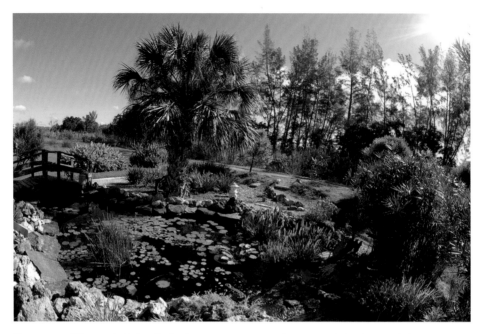

ESSENTIAL WATER: At Lakes Park, there are 150-acres of man-made freshwater lakes that were formed by a rock quarry that operated on the property in the 1960s. The water in the lakes is run off from the many roads and buildings that now surround the park. Water is a key element at the park, as its name implies, and there are many water activities to enjoy, such as kayaking. On the eighty-eight islands left from quarry activity, a bird rookery has as many as 2,000 nests during the summer months. Additionally, there's a children's splash pad, and a scenic boardwalk that is situated over the lakes. A series of ponds with aquatic plants, such a blossoming water lilies, can also be found. One pond at the botanic garden offers guest the opportunity to walk over the water across a small bridge. *Photo courtesy of Ann M. O'Phelan.*

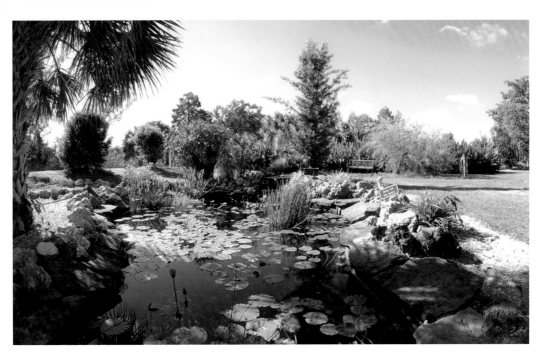

CASCADING WATER: The garden's ponds contain lilies, reed plants, and other aquatic plants. They are contained by coral rock and limestone. Another notable feature that is found in several of the ponds are waterfalls and numerous fountains. The waterfall and fountains assist the ponds by helping to break down the organic compounds that decrease the water quality. Many filtration plants are used in and around the water, as well. The water also provides soft, soothing sounds to the guests of the garden. Furthermore, the water attracts aquatic creatures such as turtles, frogs, and even alligators, which thrive along with the growing garden. *Photo courtesy of Ann M. O'Phelan.*

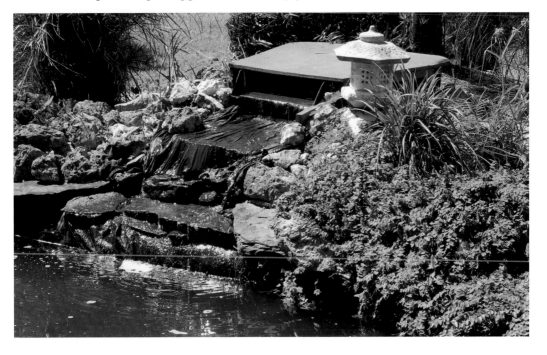

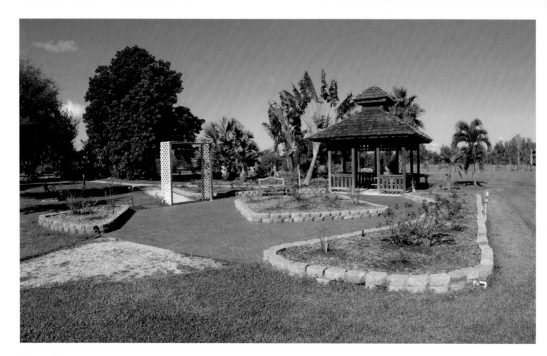

DULY DEDICATED: The brick walkway has inscribed bricks that provide guests with the chance to dedicate a brick to someone or something through the Lakes Park Enrichment Foundation. More and more inscribed bricks appear on the walkway every year. Benches, as well as trees and shrubs, have also been donated as remembrances for loved ones. Along the brick walkway, trellis was added for climbing vines, a bench was added to provide a place to rest and reflect, and a wooden pavilion was added to offer a place to cool off in the shade. With nearby blooming heritage roses, or old-fashioned roses – roses that link to gardens of the past – a sweet light scent is usually in the air. *Photo courtesy of Ann M. O'Phelan.*

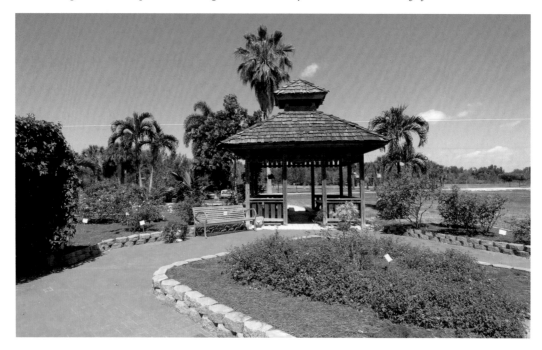

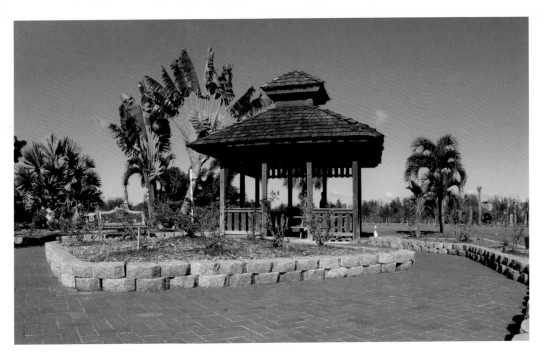

SUBTROPICAL SUCCESS: Because Southwest Florida is located in US Plant Hardiness Zone 10A, a subtropical climate, it doesn't take long for plants to grow and fill in. A subtropical climate has hot, humid summers, and mild to cool winters, so year-round, the vegetation is growing and blooming. One of the missions of the community garden is to showcase what is possible in Southwest Florida in terms of year-round gardening, with appropriate plants and flowers that grow in each of the seasons. Consequently, any time of the year is a perfect time to wander through the Lakes Park Botanic Garden and enjoy what's blooming. *Photo courtesy of Ann M. O'Phelan.*

SENSE OF COMMUNITY: A community garden – a place for locals to grow their own fruits, vegetables or flowers – was part of the original plans for the gardens. The community garden is now entering its seventh annual season. The seventy-two individual 4′ x 8′ spaces are rented by the year. Monthly on-site gardening classes are also offered by UF Extension, by local gardening experts, and by other professionals. The community garden is another way that Lakes Park strives to connect to the community with the mandate to provide a sustainable, environmentally-friendly gardening experience that is available for the gardeners and the public to enjoy. The Lee County Extension's agriculture/natural resource agent says that this community garden is the most efficient and productive in the State of Florida. The garden is always on view so visitors can stroll by, while the gate is open for visitors at gardeners' discretion. It's also open for the monthly tours, and occasionally for special events, such as National Public Garden Day, held every May. Volunteer opportunities, guided by the gardeners who always need help with high priority projects, are also available for those who would like to get their hands dirty. A nearby bulletin board offers a chance to see what is blooming at the gardens. *Photo courtesy of Ann M. O'Phelan.*

WORK AND REST: As any gardener can attest, gardening takes effort and constant vigilance, from preparing the soil, to choosing and planting the seeds, to applying fertilizers and mulch, to watering and to enjoying the harvest. However, the end results are often bountiful, and are always well enjoyed by the gardeners, and the public who come and pay a visit. Some of the harvest is actually donated by the gardeners to local food banks. After a few hours of tending to their plot in the community garden, the gardeners sometimes make their way over to the botanic garden, or they head to one of the lakes where inviting benches provide a place to rest. Gardening is widely known as being very therapeutic in many ways, as well as being a healthy form of exercise. *Photo courtesy of Ann M. O'Phelan.*

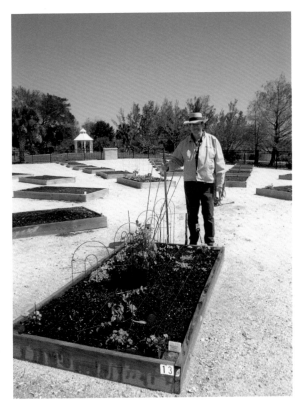

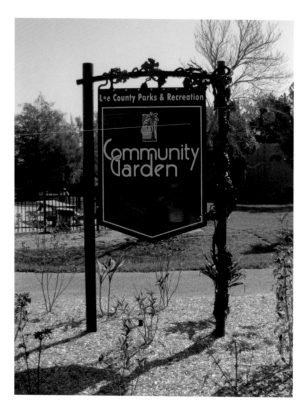

WELL MARKED: The gardens at Lakes Park are easy to navigate thanks to the paved walkways and the signs that mark the entrances. The fragrance garden is just a short walk from the community garden and the stroll over is a pleasant one thanks in part to the picturesque pond with a refreshing fountain. As the garden progresses, so does the abundance of fragrance that emanates the air. *Photo courtesy of Ann M. O'Phelan.*

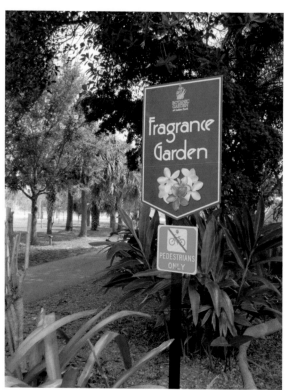

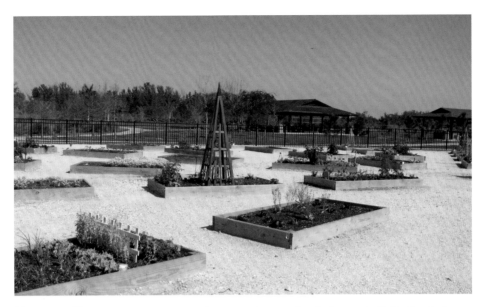

TOWERING TRELLISES: Trellises provide accents in a garden, help create distinction between spaces, and they are the perfect way to support plants and flowers, especially those of the climbing variety. Trellises can be found in the community garden, and they add flair and provide structure for vegetables like beans and cucumbers. They can also be found in the botanic garden, providing the perfect spot for flowering vines like jasmine and wisteria. Trellises have also been added to the butterfly garden for climbing vines such as Passion Flower and Dutchman's Pipe Vine, which are host plants for the larval caterpillars. Thanks to the subtropical climate found in Southwest Florida, it doesn't take long for the trellises to fill in. *Photo courtesy of Ann M. O'Phelan.*

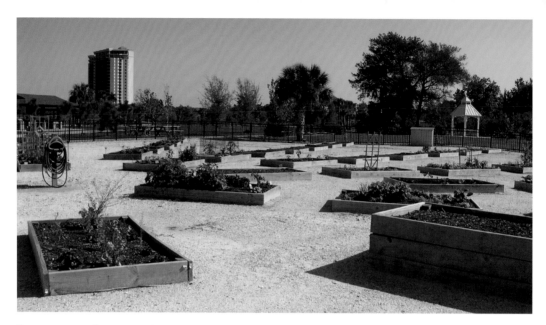

BUTTERFLIES ABOUND: The botanic garden has outdoor rooms where groups of vegetation are collectively planted. The community garden also has 4′ x 8′ beds that locals rent to create their own gardens. While the local gardeners can choose what they want to plant, butterfly and bee-friendly plants are always encouraged. Butterflies are attracted to flowering plants and shrubs, especially those with red, orange, yellow, white, pink, or purple flowers. The bright colors attract the butterflies that are searching for flowers that produce their favorite nectar. Butterflies are key pollinators and imperative to the ecology, so attracting them to the garden was always a consideration when the initial plans for the botanic garden were drafted. *Photo courtesy of Ann M. O'Phelan.*

FLOWERING DELIGHTS: At the community garden, flowering plants and flowers are often blended in with fruits and vegetables that are planted in the individual beds. Sometimes they are planted according to a particular color scheme, while other times they are blended together for an array of colors. Other considerations gardeners usually ponder when planting are the mix of textures, the seasonal and growing requirements of the plants, and whether or not the flowering plants are annuals that are replanted every year, or perennials that can grow for many years to come. Bright, bold colors can be found in both annuals and perennial plants. *Photo courtesy of Ann M. O'Phelan.*

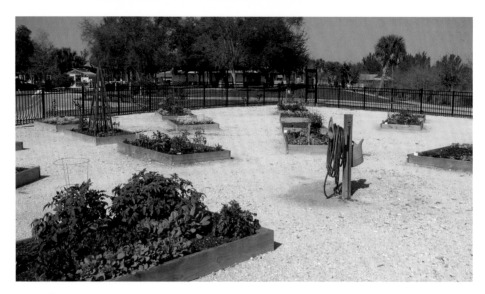

VIVID COLORS: The community garden currently offers beds for seventy-five local gardeners to personalize their very own gardens. The gardeners balance what they'd like to grow with learning what grows well in Florida's subtropics. Some gardens are planted with fruits and vegetables, such as tomatoes, spinach, and okra. Others are planted with colorful flowers such as orange marigolds (repels insects), multi-colored saliva (welcomes bees), and pink vinca (floral bouquets). Most gardeners add an herb or two including parsley, sage, rosemary, and thyme. Still others are planted with a blend of flowers, herbs, fruits, and vegetables. The colors found in both the community garden, and the botanic garden, such as in this exquisite stargazer lily, are a beautiful sight to behold for both visitors and butterflies. *Photo courtesy of Ann M. O'Phelan.*

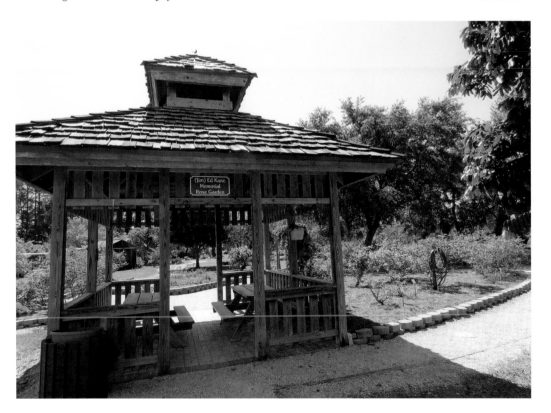

STANDING STRUCTURES: Structures, such as trellises found in the community garden and the gazebo found in the botanic garden, have important uses. The trellises provide plants with a means of climbing, while the pavilion, such as this one located in the (Jim) Ed Kane Memorial Rose Garden, provides guests with a place to rest and escape into the shade, a welcome relief especially during the summer months. Shop students at Cypress Lake High School built the gazebo in their woodworking class. The gazebo was then assembled at the garden. *Photo courtesy of Ann M. O'Phelan.*

GREENING UP: As time passed in the community garden, the original crushed shell walkways between the individual beds, naturally filled in with grasses. Also, more beds were added to the community garden so that more gardeners could participate. As the individual gardens grew, they bloomed even brighter. The individual beds reflect each gardener's vision and help support their purpose in what they plan to reap – from flowers to fruits to vegetables. The garden community, as a whole, is constantly researching and learning more about being environmentally-friendly and sustainable from year-to-year. The community also enjoys sharing this knowledge formally with various groups who come to learn, and informally with park visitors as they stop by to enjoy the gardens and ask questions. *Photo courtesy of Ann M. O'Phelan.*

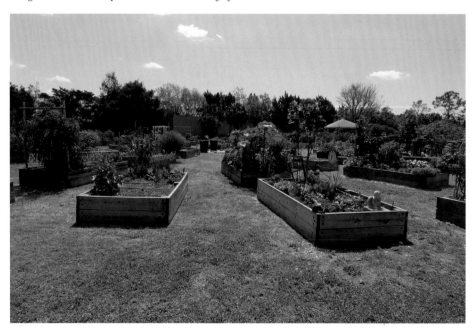

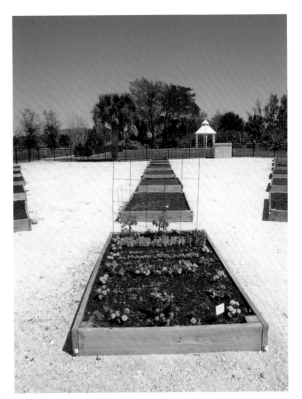

PEACEFUL FEELING: At the community garden, gardeners love getting out in the fresh air, meeting and working alongside others, sharing what they have learned, exchanging seeds and some of their harvest, feeling a sense of accomplishment, enjoying great exercise, and relishing a sense of peace. At the botanic garden, the World Peace Circle, with a message marker, adds to the importance of promoting peace on earth, throughout the park and the gardens, and worldwide. *Photo courtesy of Ann M. O'Phelan.*

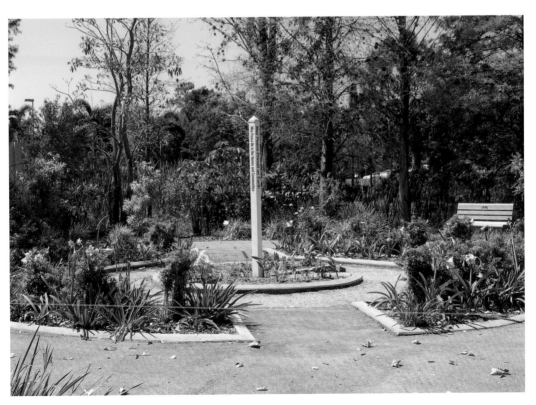

PERFECT PATHS: The paved paths at Lakes Park lead visitors to a variety of offerings. The paths lead guests from the community garden to the botanic garden, from the boardwalk to the miniature railroad and museum, and from the children's splash pad to the children's playground. These welcoming walkways are enjoyed by all of the guests who come to take pleasure in the many attractions that can be enjoyed year-round at Lakes Park. *Photo courtesy of Ann M. O'Phelan.*

THE PEACE RIVER BOTANICAL & SCULPTURE GARDENS, PUNTA GORDA

Founded as a botanical garden in 2006

Along the shoreline of the Peace River, lies a botanical garden that is scheduled to open in 2017. At twenty-seven acres, the Peace River Botanical & Sculpture Gardens will be one of the largest botanical and sculpture gardens in the State of Florida.

Roger and Linda Tetrault, who jointly formed the Tetrault Family Foundation in order to help develop their vision of the gardens become a world-class attraction, conceived a blend of both botanical and sculpture gardens. The foundation, a 501(c)(3) private nonprofit foundation, will be providing one of the largest endowments for public botanical gardens in Florida. A fifty-million-year-old palm frond fossil in stone serves as the inspiration for the logo and signature sculpture that can be found throughout the gardens. The gardens showcase world-class sculptures and botanicals that were designed to inspire, educate, and help serve homes for aquatic and terrestrial species. Sculptures by Carole Feuerman, Jacob Kulin, and Yu Zhaoyang are just a few of the artists whose sculptures were selected to be part of the gardens. Their work blends into the atmosphere yet still surprises visitors with visual interest. The gardens will feature a collection of bromeliads, hibiscus, staghorns, and trees, such as the Pearl Acacia (*Acacia podalyriifolia)*. Other botanicals, such as orchids, will be on display. In addition to the paved walkways, there will be more than 1,500 linear feet of boardwalks for guests to enjoy a view of the river and the marsh. Ten acres of the garden are located adjacent to the beautiful Peace River. The Gardens Community Center offers cascading ponds, and is where a café will be located, and events, such as weddings, can take place. Upcoming plans include the Tetrault's private residence to one day become part of the gardens and serve as a fine arts museum. Tours of the gardens will be offered and special events will be scheduled. All photos in this chapter are courtesy of the Peace River Botanical & Sculpture Gardens, unless otherwise noted.

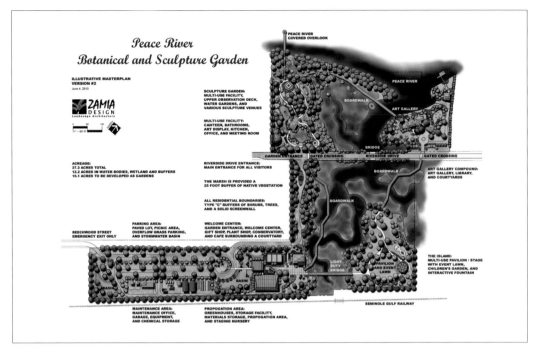

EARLY IDEAS: What began in 2006, as an idea to showcase world-class sculptures, educate visitors on local flora and preservation, share wildlife, inspire creativity, and preserve twenty-seven acres of natural habitats, began unfolding in March of 2012, when the ground-breaking ceremony with Roger and Linda Tetrault, and others who were key to the project, took their shovels and dug into the earth. This ceremony marked the time when the concept and plans for the gardens were taken to another level. (Shown: Roger Tetrault to the far left. Linda Tetrault wearing pink.)

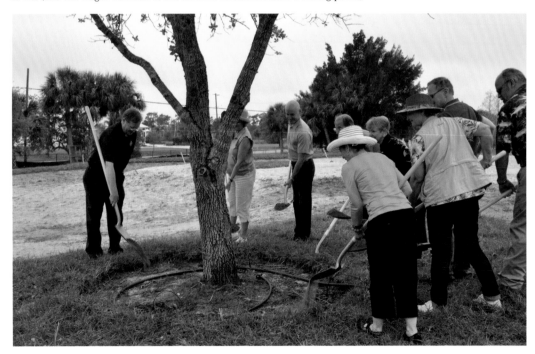

MAKING PLANS: The gardens were originally mapped out to incorporate both sculptures and botanicals into the plans. The sculptures would appear in various locations of the gardens, so that guests could enjoy each one in the backdrop of the location where it appears. All told, thirteen world-class sculptures will appear in Phase 1. The 21,000-pound *Steel Palm*, by Boston artist Jacob Kulin, is one such sculpture that is located between the Gardens Community Center and the boardwalk that leads visitors to the observation deck over the Peace River. The sculpture is impressive in size at: 22'H x 20'W x 18'D. The inspiration for both the garden's logo, and this signature sculpture, is a fifty-million-year-old palm frond fossil.

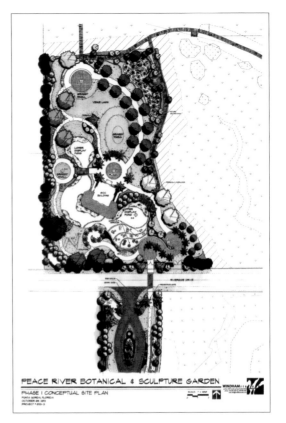

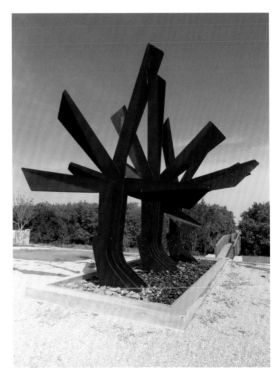

Charlotte Sun
AND WEEKLY HERALD

AN EDITION OF THE SUN
VOL. 121 NO.89 AMERICA'S BEST COMMUNITY DAILY SATURDAY MARCH 30, 2013 www.sunnewspapers.net $1.00

A distinguished graduate of Naval Academy

By AL HEMINGWAY
SUN CORRESPONDENT

PUNTA GORDA — Retired U.S. Navy Capt. Roger Tetrault considers himself a lucky man.

He believes he was among the last to be chosen for the U.S. Naval Academy in 1959 because of the date of his acceptance telegram, May 28, a mere five days before his induction. He graduated in 1963, in the top half of his class, and became a naval aviator, only to narrowly escape death when his A-1 Skyraider crashed on the deck of the USS Midway.

When the USS Turner Joy was hit by an enemy shore battery off the coast of North Vietnam in 1967, the flying shrapnel came dangerously close to igniting the ammunition stored on board, and wounded three crew members.

On March 22, Tetrault, 71, was honored with the Distinguished Graduate Award for his lifetime commitment to service, personal character and distinguished contributions to the country.

The medal was created

SUN PHOTO BY AL HEMINGWAY
Roger Tetrault wearing his Distinguished Graduate Award from the Naval Academy.

by the Naval Academy Alumni Association and Foundation, and first was awarded in 1999. Out of the 40,000 living alumni of the academy, only 56 graduates have received the prestigious medal — and only 37 of them are still living.

"I know that I am lucky to be alive," Tetrault, who retired in 1985 from the Navy Reserve, said in

his acceptance speech to the Class of 2013.

Tetrault's accomplishments, as a Navy officer and a civilian, are noteworthy. In addition to his awards and decorations, which include the Navy Commendation Medal with Combat V, the Combat Action Ribbon and a Meritorious Unit Citation, he was instrumental in improving

the nuclear reactors used on Navy ships, served on the National Aeronautic and Space Administration Advisory Council Committee, served as a member of the committee that investigated the Space Shuttle Columbia disaster, and was on the National Research Council Committee to assist in extending the life of the Hubble Space Telescope.

"The one thing I am most proud of is being put in charge of developing nuclear reactors for the Navy in the 1970s," he said. "I started with just four people, and it grew into the most advanced, classified, fully automated project at that time in the U.S."

Because the Navy had multiple reactors on their vessels, Tetrault was named project manager, whose job was to create a single reactor that would use less-expensive fuel. Ultimately, his concept became a reality, and saved the government an estimated $10 billion to $15 billion in the cost of additional reactors, fuel

costs and equipment overhauls. A few years later, as vice president and general manager of the Naval Nuclear Fuel Division, his company became the sole supplier of reactors for the U.S. Navy.

"That was a point of honor for me," he said.

When the Space Shuttle Columbia tragically disintegrated upon returning to Earth in February 2003, Tetrault received a telephone call and was asked to be a part of the investigation into the cause of the accident.

"I was one of five people on the technical side that participated," he said. "They collected 67,000 parts that had been scattered over Texas and Louisiana, and placed them in the shuttle hangar at the Kennedy Space Center. I had to select which pieces had to be analyzed to find out what went wrong. It was like a giant jigsaw puzzle."

Tetrault said they now know with great certainty what caused the fatal meltdown of the aircraft. A piece of

PHOTO PROVIDED
Roger Tetrault, when he graduated from the Naval Academy in 1963.

foam, about the size of a Styrofoam cooler, had come off the external tank and struck the leading edge of the left wing, putting a 6-inch hole in it and damaging the ship's thermal protection system. Upon re-entry, the intense heat from the gases was like a fire hose shooting inside the wing, causing it to break off.

In his speech to the class of 2013, Tetrault summed up his career and accomplishments.

"I really believe that the key to life is to be able to end it believing that you were able to achieve something of value while having laughed loudly, smiled broadly and loved deeply," he said.

BACKGROUND STORIES: Roger Tetrault's impressive background includes being a Distinguished Graduate of the Naval Academy and receiving the Navy Commendation Medal with Combat V, the Combat Action Ribbon, and a Meritorious Unit Citation; his efforts also helped improve the nuclear reactors on Naval ships. Furthermore, Tetrault served on the National Aeronautics and Space Administration Advisory Council, as well as a member of the committee that investigated the *Space Shuttle Columbia* disaster. He was also on the National Research Council Committee to assist in extending the life of the Hubble Space Telescope. Tetrault is the retired CEO and Chairman of the Board of McDermott International, one of the world's largest off-shore oil companies. Roger Tetrault, and his wife, Linda, who has a PhD in industrial psychology, traveled worldwide to acquire their knowledge and deepen their interest of botanicals and art, particularly sculptures.

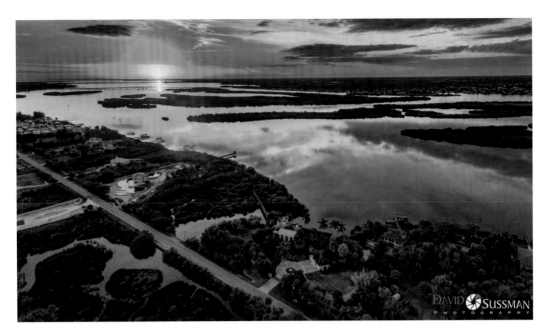

CAREFULLY CONSTRUCTED: The Tetrault residence and guesthouse are located on the Peace River in Punta Gorda. Both their private residence and guesthouse will one day become part of the gardens and will serve as a fine arts museum. Their residence, guesthouse, and the Gardens Community Center, were designed by Dan F. Sater II, FAIBD/CPBD/CGP, an internationally-renowned Certified Professional Building Designer and Certified Green Professional. *Aerial photo courtesy of David Sussman.*

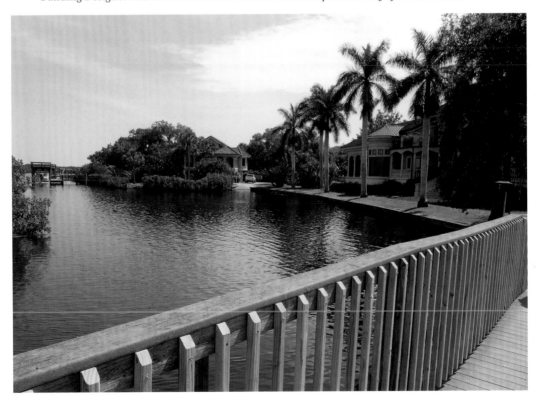

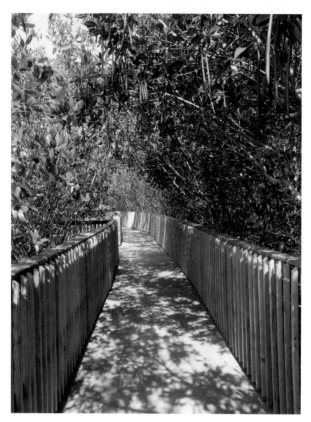

WONDERFUL WATER: Water is an important feature of the gardens as they are adjacent to the Peace River. There are also wetlands located on the property. The present 840 linear feet of boardwalks (which will ultimately total 1,500 linear feet), allow guests to enjoy prime viewing of both the river and the marsh. A variety of aquatic and terrestrial species can be seen from these expansive boardwalks. Part of the mission of the gardens is to help provide natural habitat for the species that can be found on the twenty-seven acres. Today's visitors, as well as generations of visitors to come, will have a place to enjoy the natural beauty.

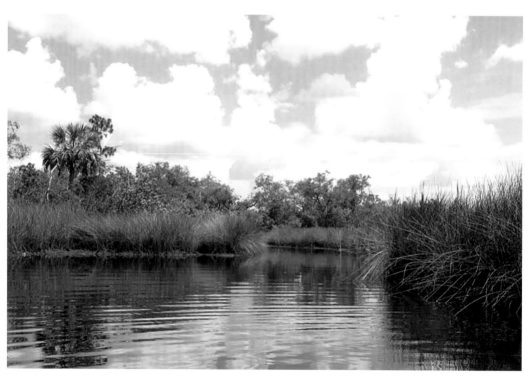

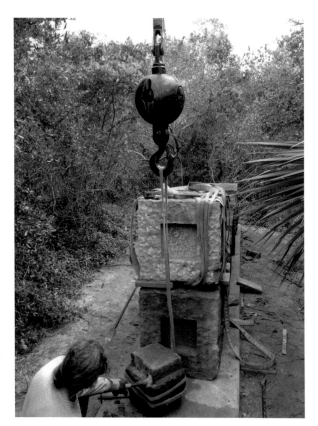

HOT ROCKS: One of the thirteen sculptures that was incorporated into the garden's Phase 1 plan, is *Keel*. The sculpture was built in Indonesia by internally-acclaimed Turkish artist Kamal Tufan, who was originally an industrial engineer. The sculpture, composed of twenty-three individually-sculpted lava rocks, weighing as much as 5,000 pounds, is located in a patch of upland within the marsh. The sculpture was created in Southeast Asia and transported to the gardens where a 120-foot crane was used to carefully place the stones without disturbing the marsh.

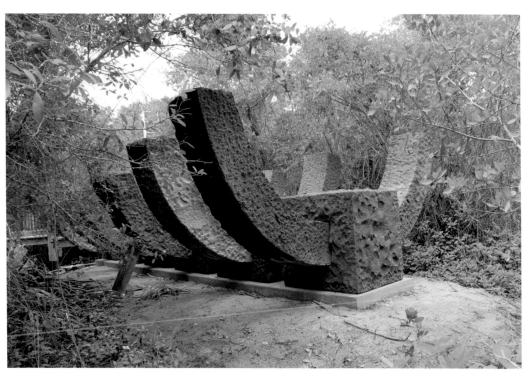

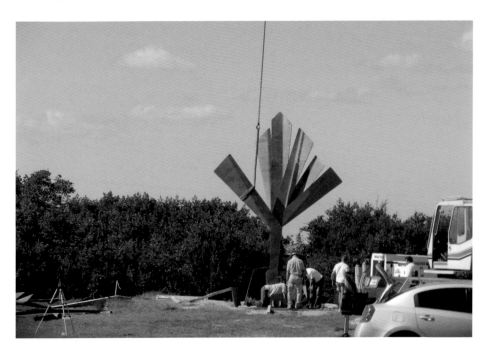

SIGNATURE SCULPTURE: The signature sculpture – 22-foot tall, 21,000-pound *Steel Palm*, by award-winning Boston artist Jacob Kulin –was created from one-foot-thick COR-TEN® steel plates. The sculpture was installed in 2012, and was designed to rust to a patina over years of weathering. The sculpture is positioned at a high point in the Sculpture Garden. This elevated height enables visitors to gain different perspectives of the sculpture as they approach it from different directions and distances. Palm fronds are traditionally symbols of peace, triumph, and eternal life, and so the relevance of the frond is fitting for this sanctuary of art and nature. The crane-assisted installation can be seen at www.kulinmodern.com/SteelPalm.html.

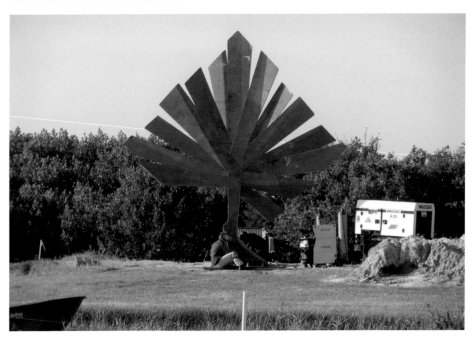

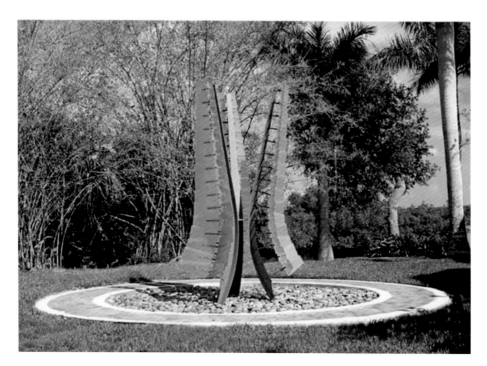

GORGEOUS GLASS:
Glass Fronds was also designed by Jacob Kulin, who created the garden's signature piece *Steel Palm*. The 13′H x 6′W *Glass Fronds* sculpture was created in 2008, with plate glass, anodized aluminum, and stainless steel. The sculpture was placed just outside the west side of the Tetrault's private residence. The leaves of a palm are generally referred to as fronds. The base of the frond is attached to the palm tree's trunk.

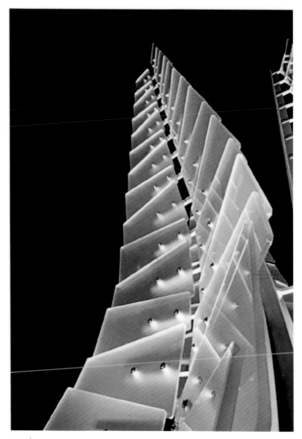

THREE TRELLISES: Three tree trellises were designed and made by Stefani & Company of Orchard Lake, Michigan. Cary Stefani led the metal-smith team who worked on the trellises. While the bases of the trellises were all made in Michigan, the vertical rebar structures were created on-site. Each of the trellises stands 20′ tall, and each trellis is 22′ in diameter at the top. All three stand at the far end of the entry drive leading to the parking lot that is located on the south side of Riverside Drive. Each trellis will be planted with a different color of climbing bougainvillea, such as pink, purple, orange, yellow, white, or magenta, which will eventually fill in like a vase. Bougainvillea is a thorny ornamental vine that offers bright flowers. *Example photo courtesy of Christopher Paul, Outdoor Spaces.*

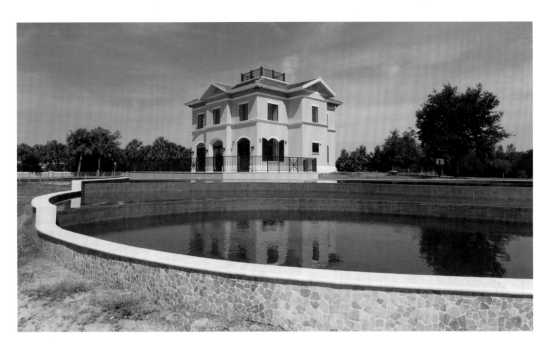

CASCADING WATERS: The Gardens Community Center was designed by Dan Sater II, FAIBD/CPBD/CGP, an internationally-renowned Certified Professional Building Designer and Certified Green Professional, who also designed the Tetrault's residence and guesthouse. The center is where a café will be located and events, such as weddings, can take place. The center is also nearby the garden's signature piece, *Steel Palm*, created by Jacob Kulin. Surrounding the center is a series of ponds that cascade into one another. When water cascades, air is added which keeps the water from becoming stale. Cascading water also represents movement, life, and wisdom. *Aerial photo courtesy of David Sussman.*

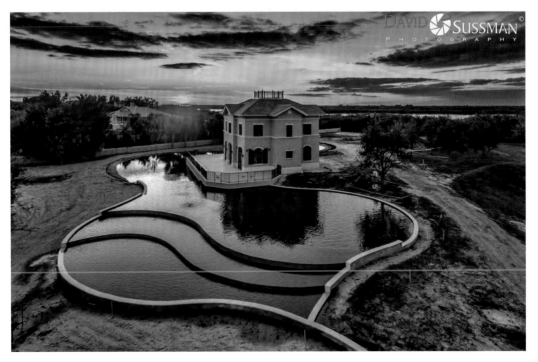

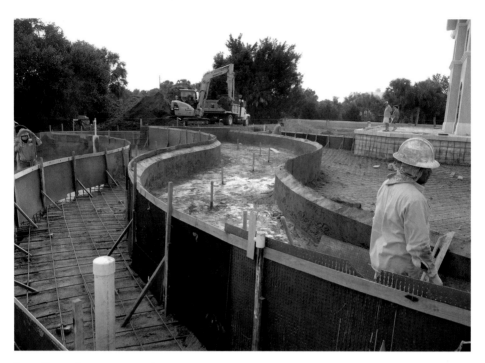

LIFE-SIZED SCULPTURES: The ponds that are located right outside of the Gardens Community Center add to the peaceful ambience of the gardens. They are also the setting for *Bibi on the Ball*, a hyper-realistic sculpture by sculptor, Carole Feuerman, of New York City. Feuerman's pieces are in fourteen major modern art museums around the world. The sculpture was created in bronze and stainless steel, and will find its home nearby the lower pond outside of the Gardens Community Center, where it will be surrounded by beach sand.

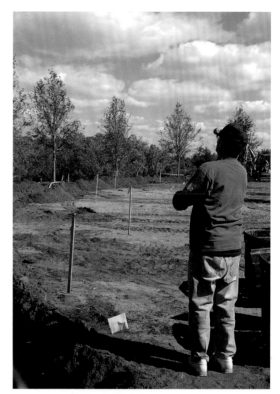

CATHEDRAL CANOPIES: Sixteen Cathedral Oaks *(Quercus virginiana)*, were planted in rows in the grounds outside of the Gardens Community Center. Cathedral Oaks grow forty to sixty-feet in height and provide a lot of shade. The stunning trees are bell shaped with dense branches and leaves. These evergreens are known to provide consistency in landscaping, privacy, and shade. As they fill in, no doubt, Spanish moss will hang from their branches adding to the Old Florida effect. Roger Tetrault is shown here overlooking the plantings.

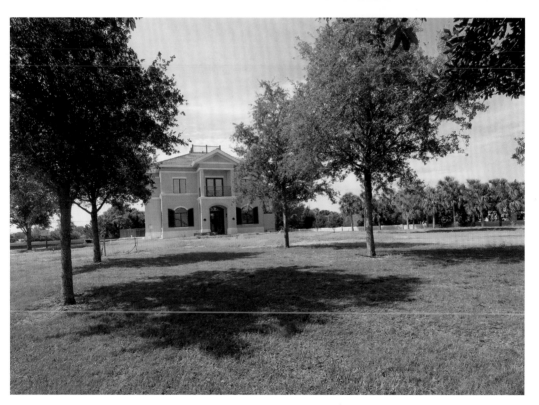

STUNNING STAGHORNS: Joni Thompson, of Port Charlotte, Florida donated a twenty-year old staghorn fern specimen *(Platycerium bifurcatum)*, weighing roughly 200-pounds. Staghorns are native to the Philippines, Madagascar, Southeast Asia, Australia, Indonesia, Africa, and America. They are epiphytes, or plants, that obtain moisture and nutrients from air and rain. In the case of staghorn ferns, they are generally found growing harmlessly on tree trunks, branches, or rocks. The gardens, so far, have a collection of six different staghorn species, which will undoubtedly grow in size and quantity as time goes on.(Roger Tetrault is shown here.)

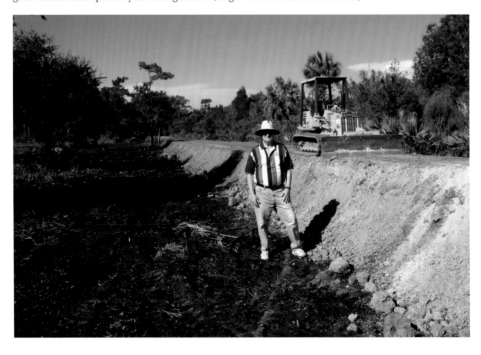

TWO PERSPECTIVES: The sculpture, *Steel Palm*, by artist Jacob Kulin, is placed on a high point in the Sculpture Garden for optimum viewing. The sculpture is situated between the Gardens Community Center and the observation deck that rests on the Peace River. The observation deck and boardwalk leading to it, offer guests a chance to see a wide view of the 106-mile long Peace River that the Gardens are adjacent to. Birds and wildlife can be enjoyed at the observation deck, as well as a peaceful rest. *Both photos courtesy of Joan Keeney Photography.*

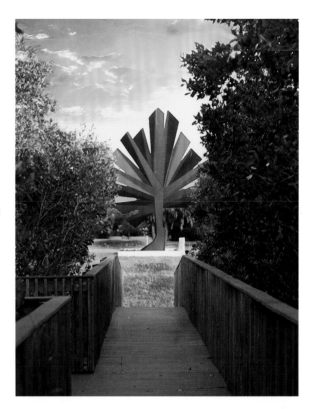

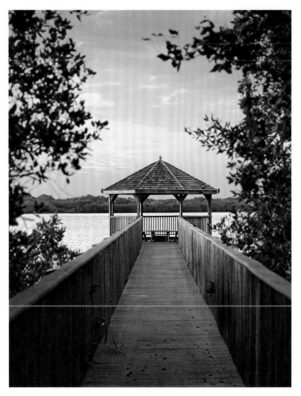

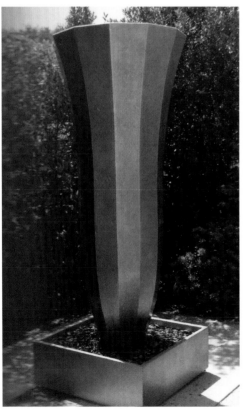

FLOWING FLOWERS: The flowering plant Spanish moss (*Tillandsia usneoides*), grows upon larger trees, such as the southern live oak (*Quercus virginiana*), and bald cypress (*Taxodium distichum*), which are often found growing in the lowlands and savannas of southeastern United States, including Texas, Florida, Arkansas, and Virginia. Also representing a flowering plant is the nine-foot tall stainless steel sculpture, *Fleur*, created by internationally-recognized sculptor, Archie Held, of Richmond, California. The sculpture is actually a fountain with water that spills over the top edge.

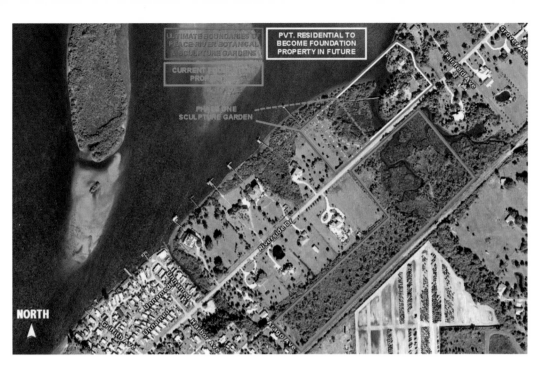

ULTIMATE BOUNDARIES OF
PEACE RIVER BOTANICAL
& SCULPTURE GARDENS

CURRENT BOUNDARIES OF
PROPERTY

PVT. RESIDENTIAL TO
BECOME FOUNDATION
PROPERTY IN FUTURE

PHASE ONE
SCULPTURE GARDEN

NORTH

DISTINCTIVE DONATIONS:
The boundaries of The Peace River Botanical & Sculpture Gardens are located on both sides of Riverside Drive. On the south side of the street, along with botanic wonders, sculptures, and parking, lies a twelve-foot tall, forty-year old ponytail palm (*Beaucarnea recurvata*), also donated by Joni Thompson of Port Charlotte, Florida. The Tetrault Foundation hopes that others will follow Thompson's steps and make additional large plant and tree donations.

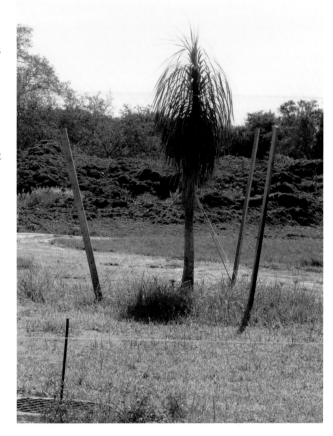

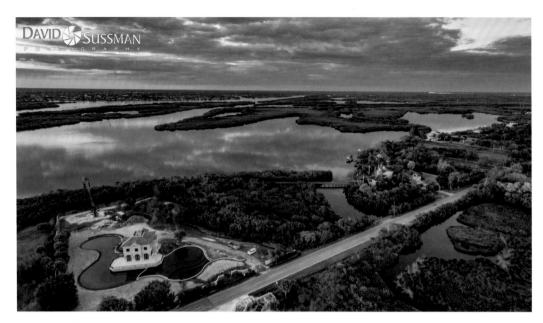

EXQUISITE VIEWS: The present 840 linear feet of boardwalks (which will ultimately total 1,500 linear feet), allow guests to enjoy prime viewing of both the river and the marsh. The cascading ponds at the Gardens Community Center, Riverside Drive and the private residence and guesthouse of the Tetraults, can be see here from a bird's eye view. The private residence looks out over the Peace River and will one day become part of the gardens and serve as a fine arts museum. *Aerial photo courtesy of David Sussman.*

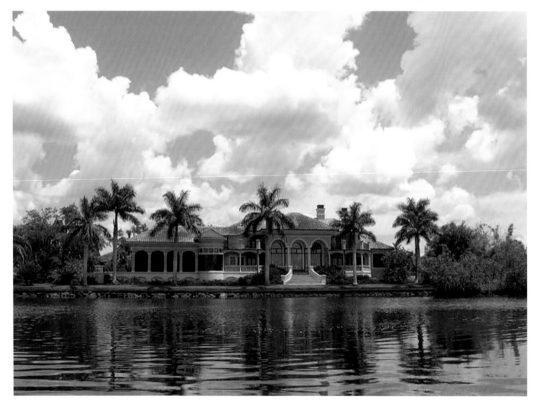

ACKNOWLEDGEMENTS

This book was made possible thanks to the generous assistance from Brooke LeMaire, Marketing Associate, Fairchild Tropical Botanic Garden; Keith Clark, Managing Director & Director of Development, Flamingo Gardens; Elizabeth Kostecki, Curator of Wray Home/Historian, Flamingo Gardens; Lorenzo Cassina, Photographer (Flamingo Gardens); Courtney Jolly, Director of Marketing and Public Relations, Naples Zoo at Caribbean Gardens; Betsy Barbour, Lakes Park Community Garden; Nancy Heriegel, Lakes Park Garden Coordinator; Susan Moore, Lakes Park Enrichment Foundation, Dick Mcconville, Former Lakes Park Garden Volunteer; Roger and Linda Tetrault, Founders, Peace River Botanical & Sculpture Gardens; Marilyn Smith Mooney, Executive Director & Vice Chair, Peace River Botanical & Sculpture Gardens;and David Sussman, DWSussman Photography (The Peace River Botanical & Sculpture Gardens).

TO VISIT THESE GARDENS:

FAIRCHILD TROPICAL BOTANIC GARDEN
10901 Old Cutler Rd, Miami, FL 33156
(305) 667-1651
www.fairchildgarden.org

FLAMINGO GARDENS
3750 S Flamingo Road, Davie, FL 33330
(954) 473-2955
www.flamingogardens.org

NAPLES ZOO AT CARIBBEAN GARDENS
1590 Goodlette Rd, Naples, FL 34102
(239) 262-5409
napleszoo.org

LAKES REGIONAL PARK
7330 Gladiolus Drive, Fort Myers, FL 33908
(239) 533-7575
www.lakesparkenrichmentfoundation.org

PEACE RIVER BOTANICAL & SCULPTURE GARDENS
5800 Riverside Drive, Punta Gorda, FL 33982
www.peacerivergardens.org

Other Southern Florida Botanical Gardens:

AMERICAN ORCHID SOCIETY VISITOR CENTER AND BOTANICAL GARDEN
www.aos.org

BOTANIC GARDENS AT KONA KAI RESORT
www.konakairesort.com

DEERFIELD BEACH ARBORETUM
www.deerfield-beach.com

FLORIDA INSTITUTE OF TECHNOLOGY BOTANICAL GARDENS
www.fit.edu

JOHN C. GIFFORD ARBORETUM – UNIVERSITY OF MIAMI
www.bio.miami.edu

HEATHCOTE BOTANICAL GARDENS
www.heathcotebotanicalgardens.org

THE KAMPONG
ntbg.org/gardens/kampong.php

KEY WEST BOTANICAL FOREST AND GARDEN
www.keywestbotanicalgarden.org

MCKEE BOTANICAL GARDEN
www.fruitandspicepark.org

MIAMI BEACH BOTANICAL GARDEN
www.mbgarden.org

MONTGOMERY BOTANICAL CENTER
www.montgomerybotanical.org

MOUNTS BOTANICAL GARDEN
www.mounts.org

ORMOND MEMORIAL ART MUSEUM AND GARDENS
Ormondartmuseum.org

PALMA SOLA BOTANICAL PARK
palmasolabp.com

PORT ST. LUCIE BOTANICAL GARDENS
pslbotanicalgardens.org

THE SOCIETY OF THE FOUR ARTS GARDENS
www.fourarts.org

TROPICAL RANCH BOTANICAL GARDEN
www.tropicalranchbotanicalgardens.com

UNBELIEVABLE ACRES BOTANIC GARDEN
www.unbelievableacresbotanicalgarden.org

UNIVERSITY OF SOUTH FLORIDA BOTANICAL GARDENS
gardens.usf.edu

Other Botanical Gardens Mentioned:

KEW GARDENS
Royal Botanic Gardens,
Kew Richmond, Surrey TW9 3AB
020 8332 5655
www.kew.org

MISSOURI BOTANICAL GARDEN
4344 Shaw Blvd., St. Louis, Missouri 63110
(314) 577-5100
www.missouribotanicalgarden.org

UNITED STATES BOTANIC GARDEN
100 Maryland Ave SW, Washington, DC 20024
(202) 225-8333
www.usbg.gov